The 1970s
Ireland in Pictures

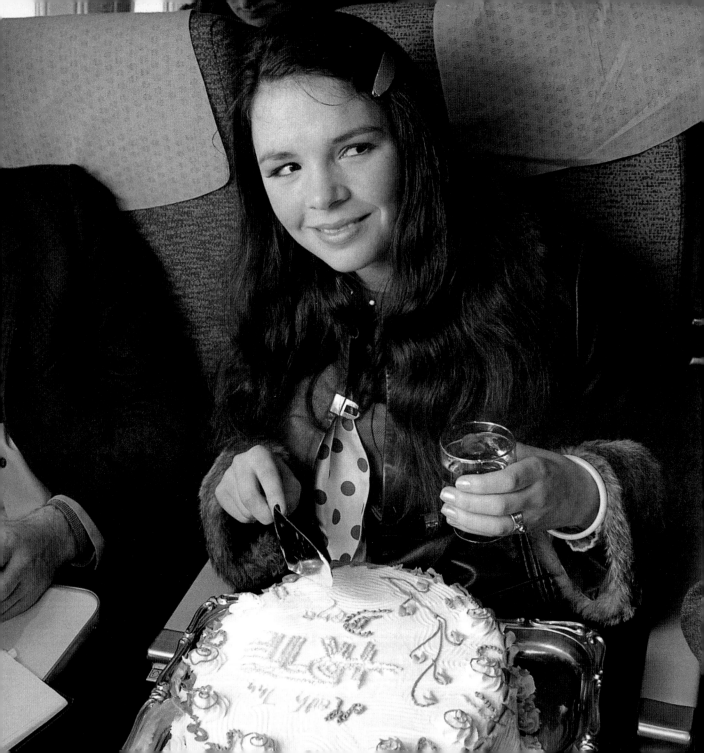

The 1970s

Ireland in Pictures

Lensmen Photographic Archive

THE O'BRIEN PRESS
DUBLIN

Opposite
Dana (Rosemary Brown) returning home in
triumph from her win in the Eurovision Song
Contest. Her song, 'All Kinds of Everything',
composed by Derry Lindsay and Jackie
Smith, reached No 1 in the Irish and British
charts. It was Ireland's first victory in the
contest.

23 March 1970

First published 2013 by The O'Brien Press Ltd.,
12 Terenure Road East, Rathgar,
Dublin 6, Ireland.
Tel: +353 1 4923333; Fax: +353 1 4922777
E-mail: books@obrien.ie
Website: www.obrien.ie

ISBN: 978-1-84717-320-1

17 Nottingham St., North Strand, Dublin 3, Ireland. Tel: +353 1 8197738
Email: info@lensmen.ie Websites: www.lensmen.ie, www.irishphotoarchive.ie

1 2 3 4 5 6
13 14 15 16 17

Printed and bound by GraphyCEMS, Spain
The paper used in this book is produced using pulp from managed forests

Acknowledgements: It would not have been possible to put this book together
without the help of the following: Susan Kennedy, Sean Walsh, Tara Keown,
Jill Quigley, PJ Maxwell, Mark Siggins, Anthony McIntyre, Jamie Ryan, Harry
Garland, Mary Patricia Gallagher, Philip White and Julian Seymour. Thanks also
to all those who have worked in Lensmen over the past sixty years.

Opposite
Maureen Toal and Jimmy Bartley
advertising 'The Sound of Music'.
The actress had a successful
sixty-year career on stage and
TV, including Abbey Theatre
productions and TV's 'Glenroe'.
Bartley has had roles in long-lasting
TV series, including RTÉ's first
soap, 'Tolka Row', and as Bela
Doyle in 'Fair City'.
16 April 1970

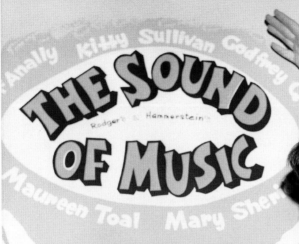

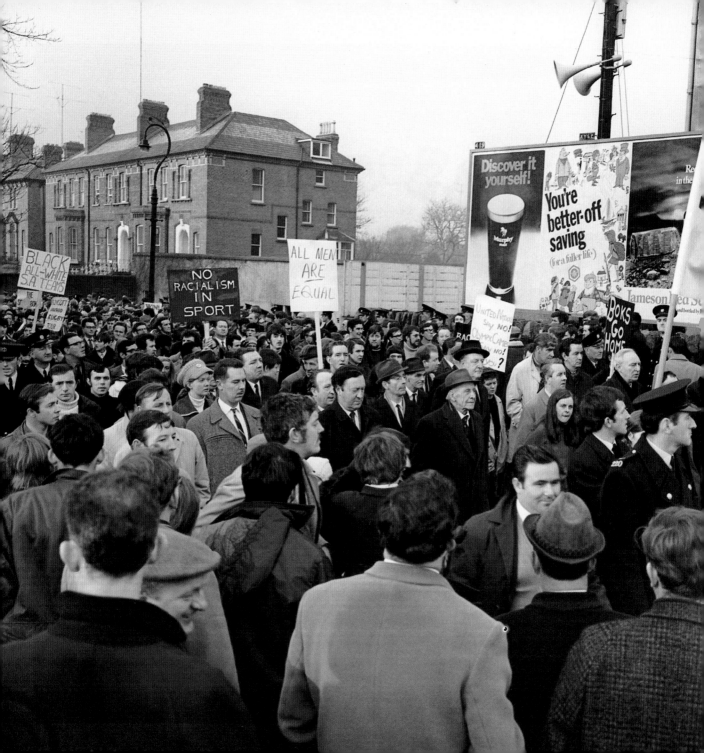

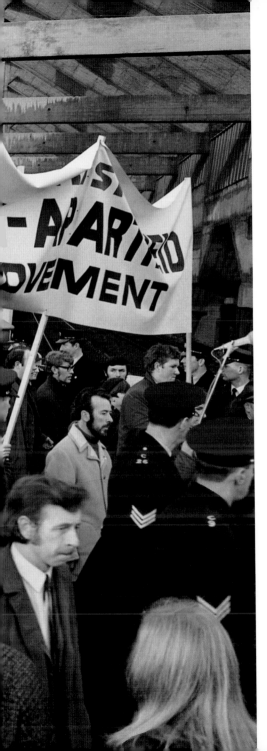

An anti-apartheid march by some 6,000 people took place to the rugby grounds at Lansdowne Road, Dublin to protest against the tour by the South African rugby team. Among the marchers are Dr Conor Cruise O'Brien, Bernadette Devlin, Donal Nevin and Dr Noel Browne.

10 January 1970

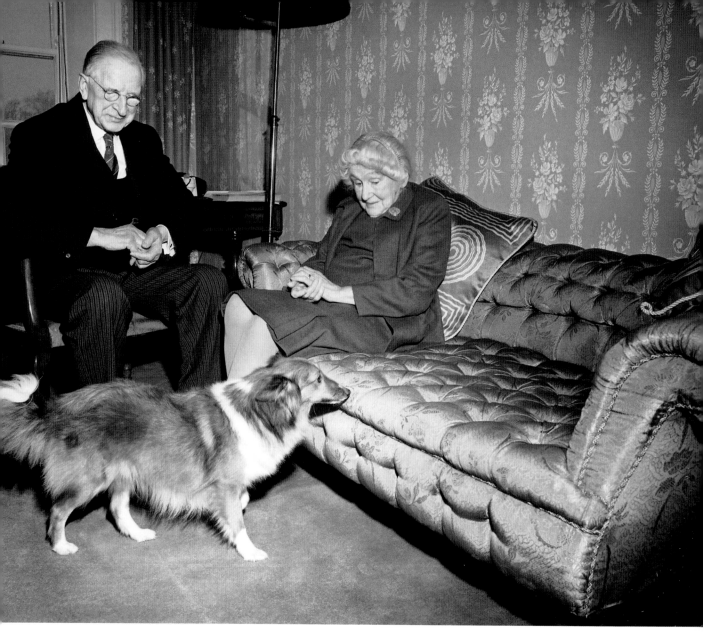

Eamon de Valera and his wife, Sinead,
celebrate their 65th wedding anniversary.

7 January 1970

The Seventies

A period of contrasts, new beginnings and major changes on the political front, the 1970s kicked off with the success of Dana, who became our first Eurovision Song Contest winner with 'All Kinds of Everything'.

In 1971, in what was seen as a historic milestone, the GAA lifted the ban on its members playing 'foreign games' such as soccer, rugby and cricket.

Another milestone, which would have far-reaching effects, was the accession of Ireland, along with Denmark and the UK, to the European Communities in 1973.

At home there was an unprecedented turnover of Presidents of the Republic. Eamon de Valera retired at the age of ninety; Erskine Childers became the fourth President of the Republic in 1973, but died suddenly in Nov. 1974, whereupon Cearbhall Ó Dálaigh became President. He resigned in Oct. 1976 having been labelled a 'thundering disgrace' by Minister Paddy Donegan for referring anti-terrorist legislation to the Supreme Court, and was replaced by Dr Patrick Hillery.

It was also a time of activism, with many taking to the streets to express their views. There were marches for peace, to protest the building of civic offices at Wood Quay, against a proposed nuclear power station at Carnsore, Co Wexford; a PAYE workers' protest against the tax system, and many more. A six-month bank strike caused chaos. In 1971 a group of Irish feminists went to Belfast by rail and returned with contraceptives, to highlight the illogicality of the law whereby owning and using contraceptive devices was legal, but they could not be sold or imported legally.

In the mid-seventies we got colour television and by 1978 another channel when RTÉ 2 came on air. Throughout the decade television audiences were entertained by the social and political satire of *Hall's Pictorial Weekly*. Its send-ups of county councillors, in the meetings of the Ballymagash Urban District Council, and of major political figures are fondly remembered. The programme was at its best during the 1973-77 term of the coalition Government, and the alter egos of Liam Cosgrave (Minister for Hardship, played by Eamon Morrissey), Conor Cruise O'Brien (Minister for Gateposts and Telegraph Poles), Dimples O' Dearly (Michael O'Leary) became as familiar as their real personas.

The 'Troubles' in Northern Ireland cast their shadow over the whole of the '70s, with the Arms Crisis in 1970, Bloody Sunday in 1972 and the reality of what our northern neighbours had been coping with for years brought brutally home with the carnage caused by the Dublin and Monaghan bombings in 1974.

Monasterevin, Co Kildare became the focus of national and international attention in 1975 as police surrounded the house where Ferenka executive Dr Tiede Herrema was being held hostage by Eddie Gallagher and Marian Coyle. He was eventually released unharmed.

We welcomed many visitors, including Muhammed Ali, who fought Al 'Blue' Lewis in Croke Park. 1979 saw the arrival of the first group of Vietnamese 'boat people'.

Perhaps the biggest and most joyful event of the decade was the visit of John Paul II in 1979 when it seemed as though the entire country went to the Phoenix Park to see him. During his three-day stay in Ireland it is reckoned that the Pope amassed an audience of almost 3 million people.

Mary Webb, Editor

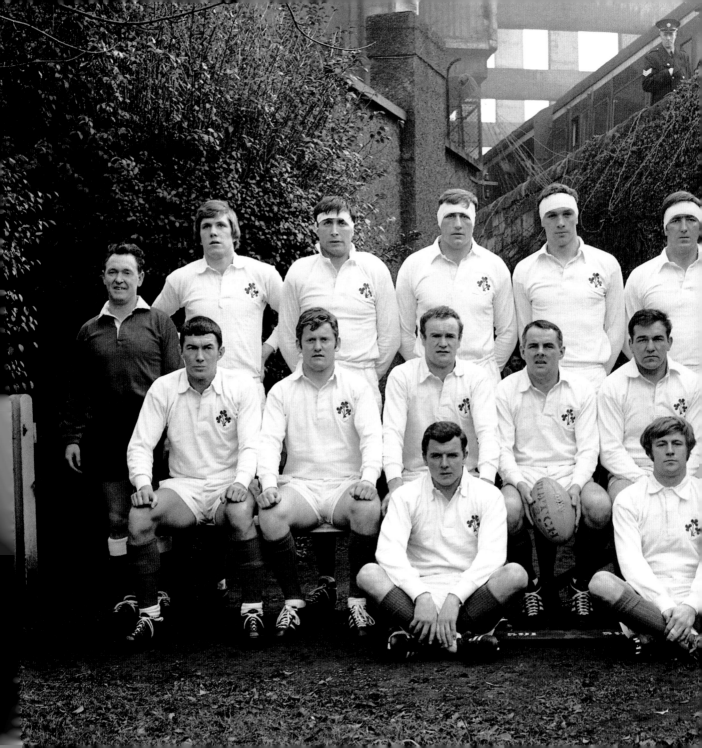

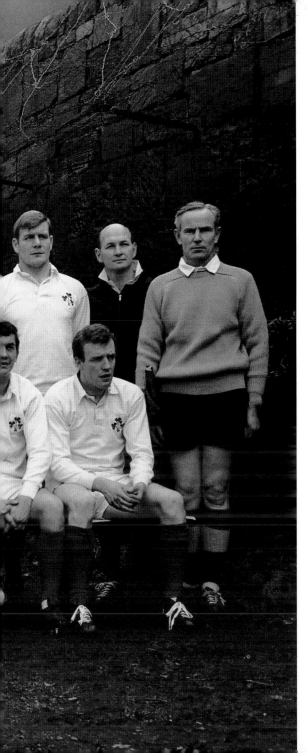

The Ireland rugby team who played South Africa in Lansdowne Road: Tom Kiernan (Capt). ATA Duggan, Barry Bresnihan, Mike Gibson, WJ Brown, Barry McGann, RM Young, Syd Millar, Ken Kennedy, P O'Callaghan, Eric Campbell, Willie John McBride, Ronnie Lamont, K G Goodall, Fergus Slattery. The game ended in an 8-8 draw.

10 January 1970

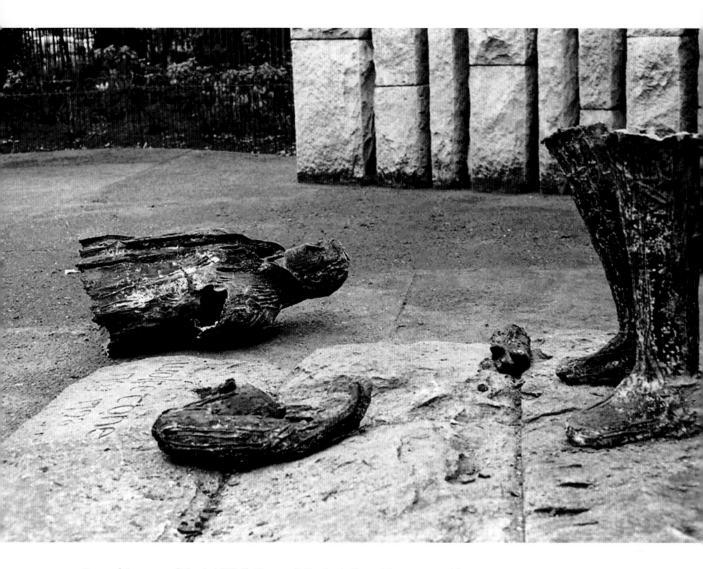

Pieces of the statue of Theobald Wolfe Tone on St Stephen's Green. The statue was blown up by a loyalist bomb. A report at the time noted that 'Huge slabs of the bronze sculpture were hurled 20 feet in the air.'

8 February 1971

The photographers: Lensmen

Andrew Farren and Pádraig MacBrian were both staff photographers in the Irish Press. Pádraig recalls that his first press photo was of cattle being loaded onto a ship on Dublin's South Wall. At the time, his wages were £1 a week!

In 1952, still only in their twenties, the pair set up Lensmen as a commercial news photographic service, initially in rented offices in Westmoreland Street, Dublin. They covered major news stories for British national newspapers and for the Cork Examiner. In the early 1960s business had expanded substantially, with Lensmen having the agency for all major Irish government departments, as well as working for PR companies and commercial businesses. They bought Nos. 10 and 11 Essex Street, and called it Lensmen House. This developed into a major agency, employing fifteen people, including five photographers. Interestingly, one of their jobs was to take photos of Irish life and events for the Irish editions of British newspapers to replace their 'Page 3 Girl' pictures, which were not considered suitable for Irish readers!

Among the stand-out events they covered were the visit of President Kennedy in the '60s and that of Pope John Paul II in 1979. Andy remembers the excitement of being on board one of the US press helicopters going to the Kennedy ancestral home in Dunganstown in 1963.

A key development for the business was the purchase of a wire machine that could transmit photos over the telephone. This was used extensively during the period of Jack Lynch's government, including the fallout from the Northern Troubles.

In the early days they used Linhof cameras with glass plates, both 9x12cm and the US standard 5x4ins. These plates survive in today's Lensmen, run by photographer Susan Kennedy, who bought the business in 1995. The meticulously recorded Lensmen archive includes a record of each day's photographic assignment as well as details of the shoot, making it a valuable visual history resource.

Andrew Farren Padraig MacBrian

This book is dedicated to Andrew Farren and Pádraig MacBrian, photographers and founders of Lensmen, for the excellence and accuracy of their work.

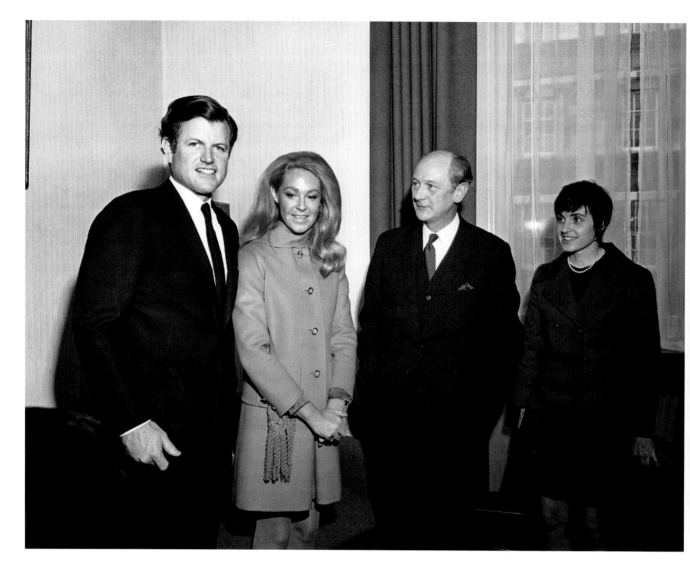

Edward Kennedy and his wife, Joan, pay
a visit to Taoiseach Jack Lynch.

4 March 1970

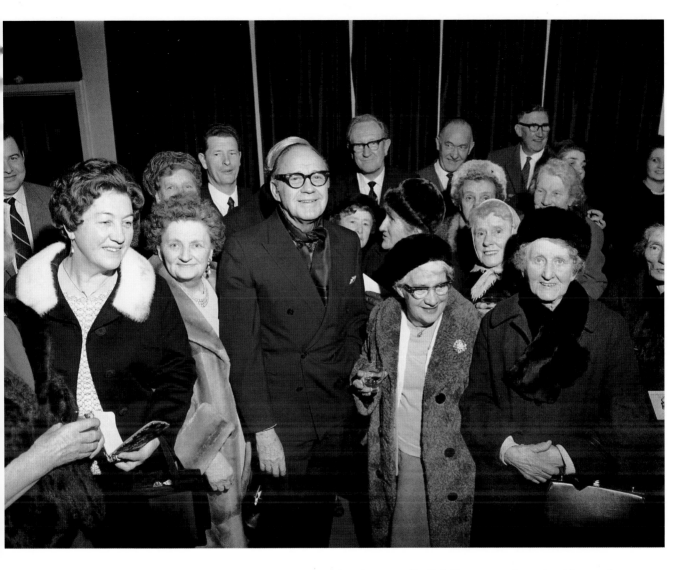

American comedian Jack Benny entertains senior citizens at the Gaiety theatre. Benny had a hugely successful career on radio and television. He was also a talented violinist but his TV character pretended to be hopeless at playing the instrument.

5 March 1970

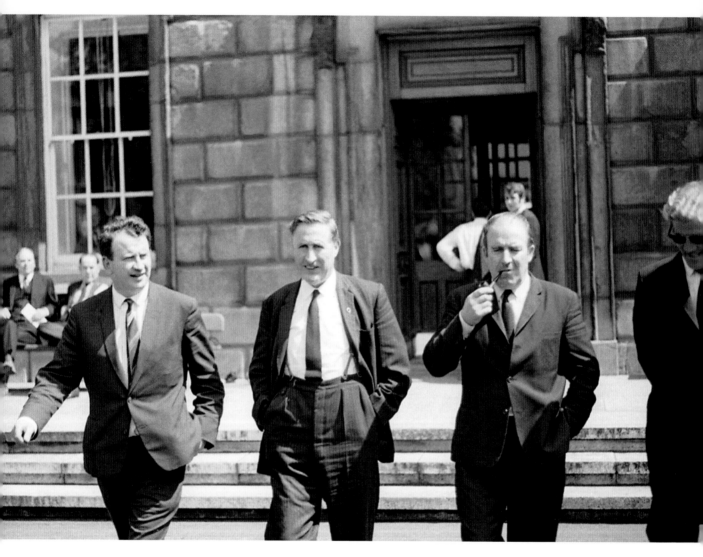

Kevin Boland (2nd left), Neil Blaney, and businessman
Gerry Jones leaving Leinster House.

3 June 1970

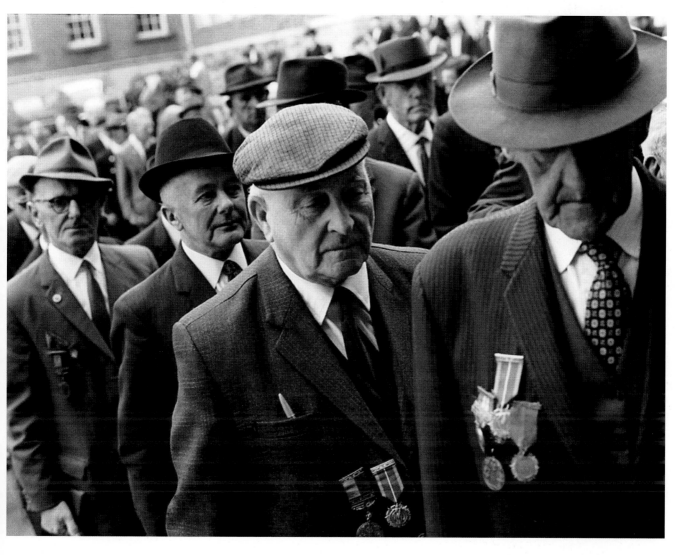

Veterans at the commemoration Mass
for Michael Collins.

20 June 1970

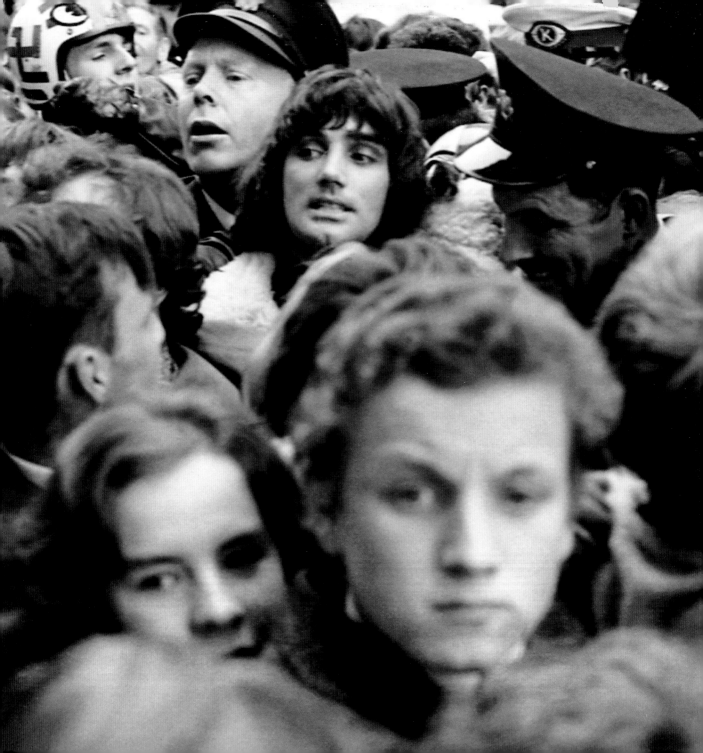

Christy Brown shares a laugh with Maureen Potter. Brown was a writer and painter who, because of cerebral palsy could only type or paint with the toes of his left foot. His best-known book, *My Left Foot*, was made into an Academy award-winning film, with Daniel Day-Lewis playing Brown.

16 September 1970

Opposite
Footballer George Best is mobbed by fans as he arrives to open Penneys Food Hall on Henry Street, Dublin.

18 August 1970

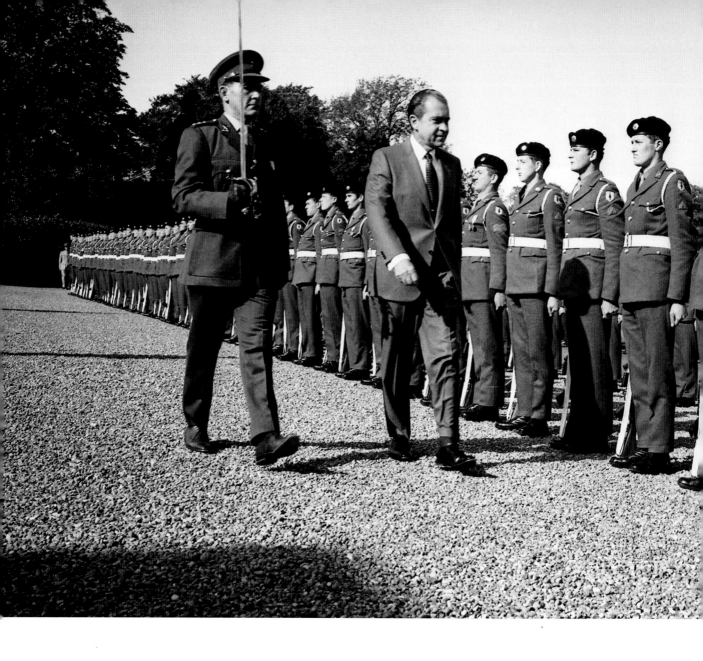

US President Richard Nixon inspects a guard of honour at Áras an Uachtaráin. During his visit, Nixon went to Timahoe, Co Kildare, from where his Quaker ancestors, Thomas and Sarah Milhous, had left for Pennsylvania in 1729.

5 October 1970

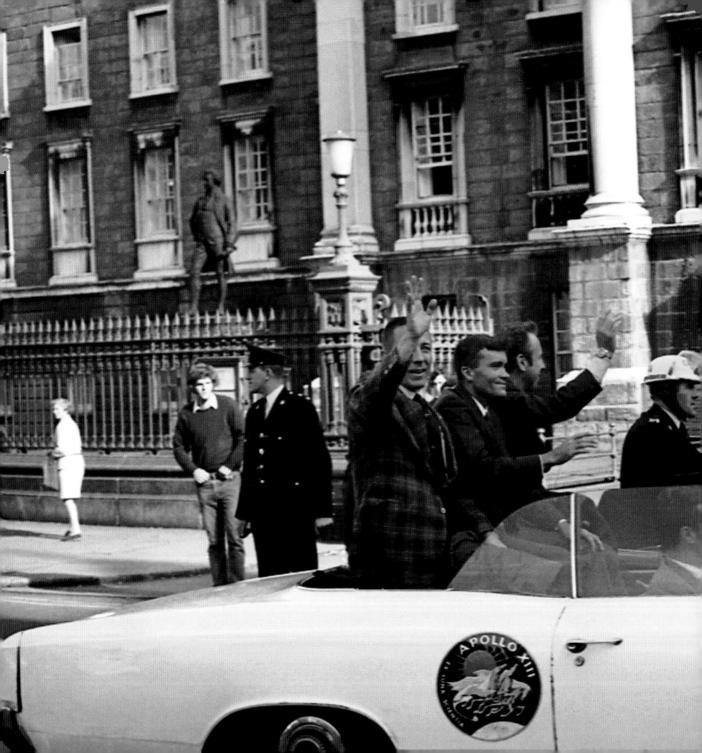

The astronauts of Apollo XIII visit Ireland as part of a European tour. James Lovell, John Swigert and Fred Haise were on a planned landing on the lunar surface, when, two days after blast-off on 11 April 1970, there was an explosion aboard the craft. Demonstrating extraordinary skill and courage, the crew managed to make emergency repairs to enable them to pilot their damaged craft back to Earth on 17 April. In car, (l to r): Haise, Lovell and Swigert

13 October 1970

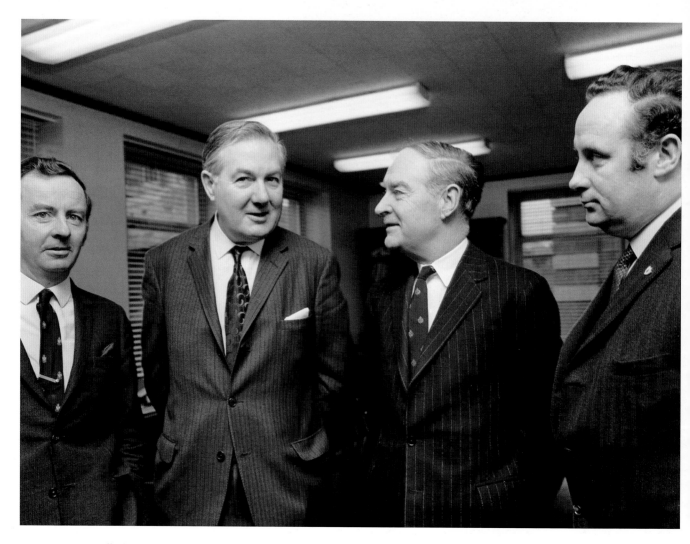

James Callaghan, MP, former British Home
Secretary (2nd from left), meets Liam
Cosgrave, leader of Fine Gael. Richie Ryan,
TD, and Paddy Harte, TD are at extreme left
and right of picture.

5 February 1971

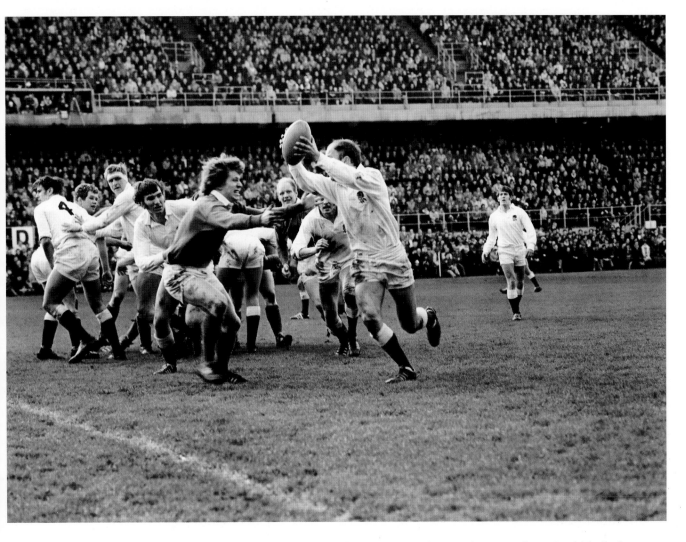

Ireland take on England in the Five Nations Championship at Lansdowne Road. The final score was Ireland 6, England 9. Bob Hiller, the England fullback, scored all his team's points with three penalties. Ireland replied with two tries from Grant and Duggan. Here, an England attacker tries to bypass Fergus Slattery in an attempt to gain ground.

13 February 1971

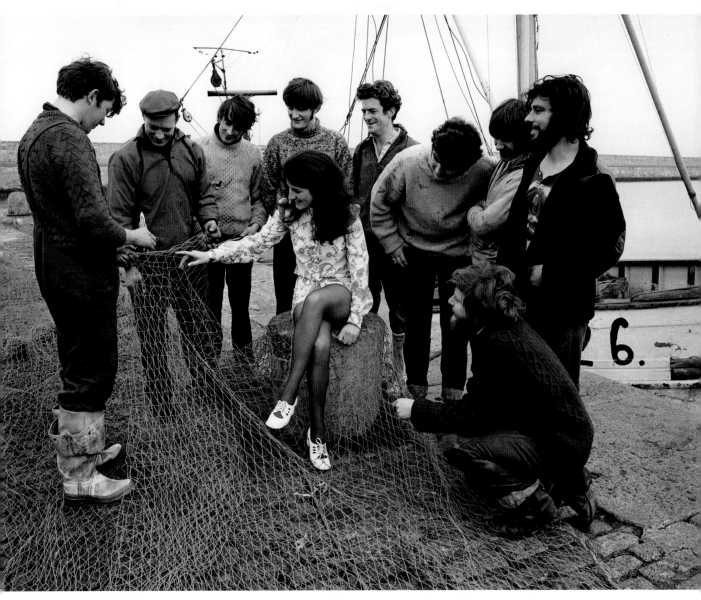

Ann Scallan, 'Miss World Fishing', is surrounded by local fishermen on the harbour wall at Dun Laoghaire. To present the more glamorous side of the fishing industry, Bord Iascaigh Mhara organised a Miss World style competition for young women within the fishing industry. The winner was selected from six finalists from fishing ports around the country.

13 March 1971

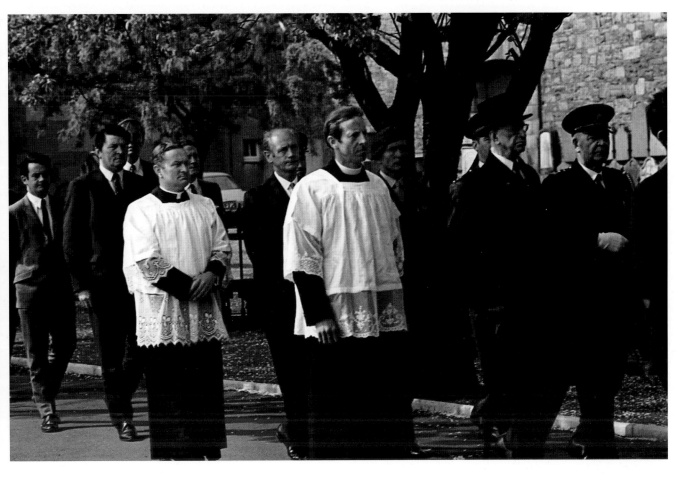

President de Valera leads the annual 1916
Commemoration Ceremony at Arbour Hill, Dublin,
where 14 of the executed leaders of the 1916 Easter
Rising are interred. Among those buried there are
Patrick Pearse, James Connolly and Major John
MacBride. Fianna Fáil politicians following the President
are Jack Lynch, Brian Lenihan Snr, David Andrews,
Gerry Cronin and Desmond O'Malley.

5 May 1971

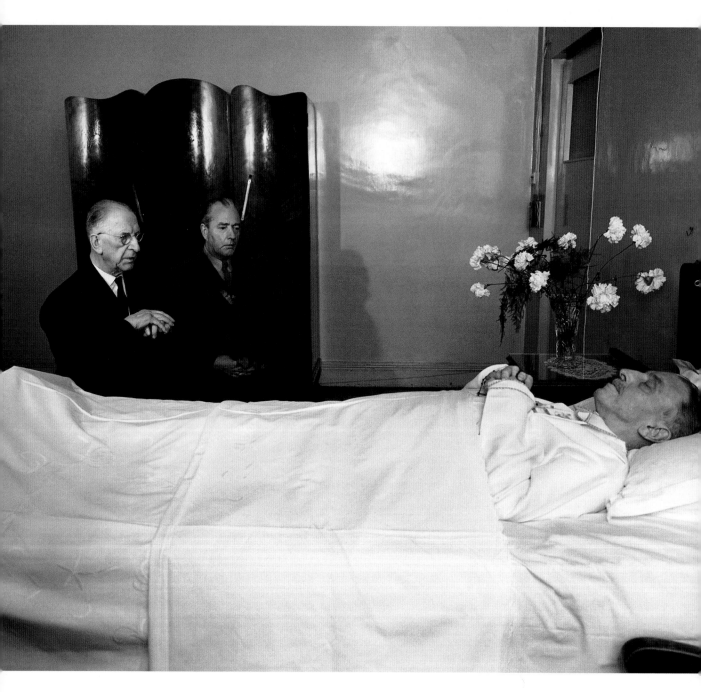

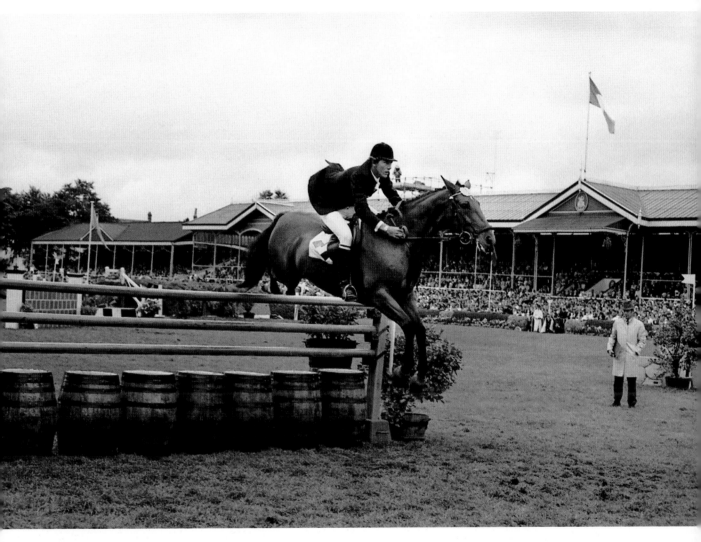

Opposite
Eamon de Valera pays his last respects to
Sean Lemass. Regarded as one of the most
prominent politicians of the 20th century,
he served as Taoiseach from 1959-1966.

11 May 1971

Eddie Macken takes a fence at
the RDS with his usual grace.

11 May 1971

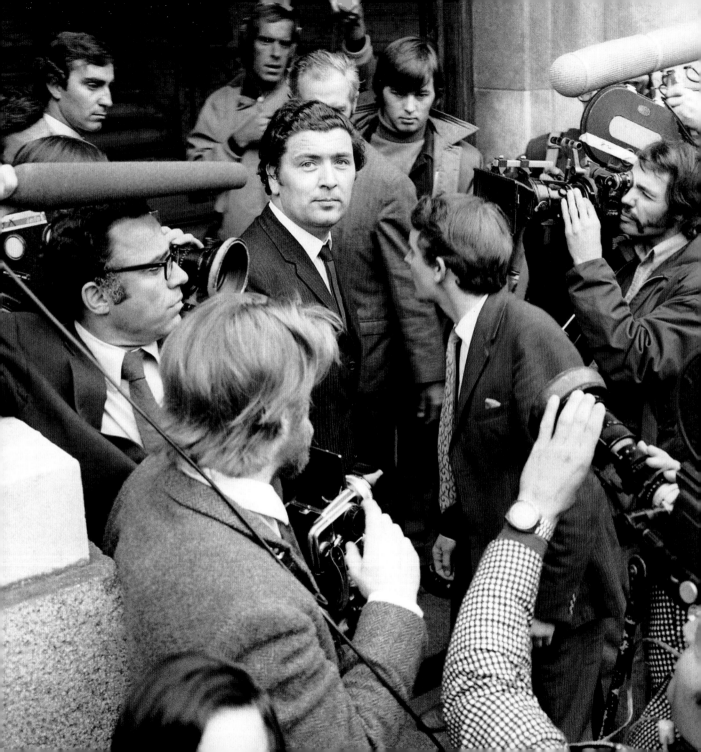

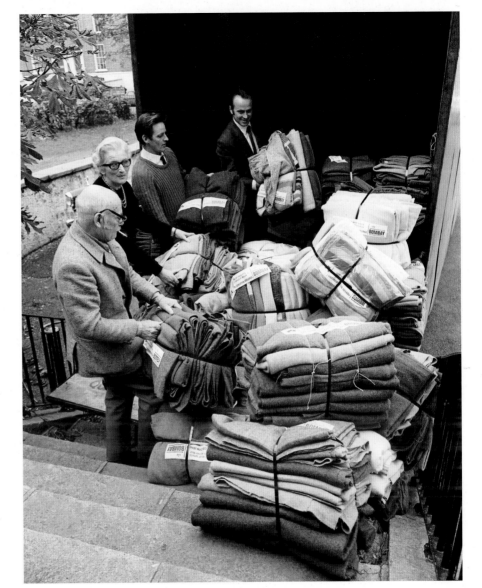

Opposite
John Hume MP and Austin Curry MP (side to camera) are surrounded by the media as they arrive at Government Buildings as part of a Northern Ireland delegation to Taoiseach Jack Lynch.

23 August 1971

Volunteers from Concern load blankets and clothing relief for refugees, to be transported via Bombay in India.

11 November 1971

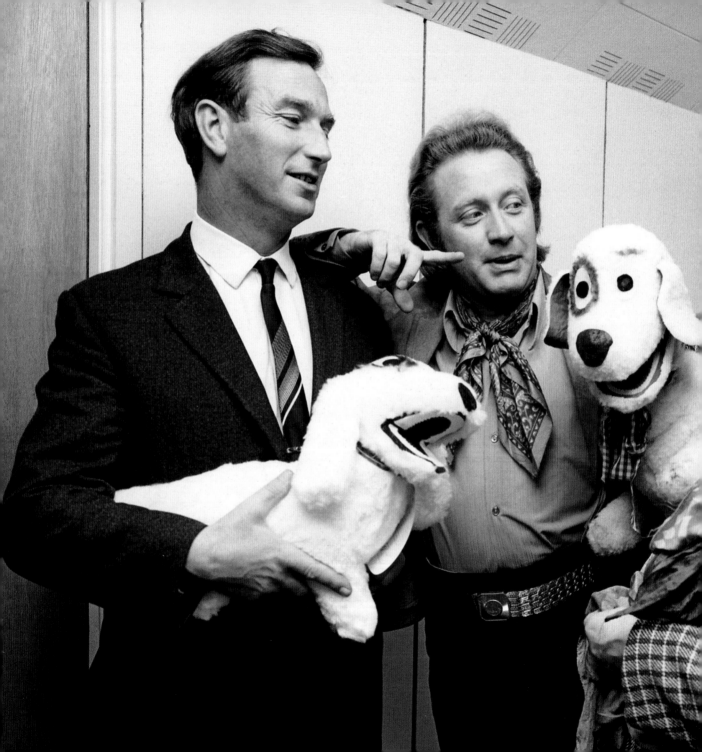

The launch of 'Judge' a new Irish-made soft toy, modelled on the famous dog from RTÉ's popular children's programme 'Wanderly Wagon'. Picture shows 'Judge' admiring his likeness. He is accompanied by (l-r), Gerard Colley, Managing Director, Orla Agencies Ltd; Bill Golding, who played 'Rory' on the series, and Eugene Lambert, who played 'O'Brien' as well as being the puppeteer who designed the original dog. 'Judge' also featured in TV road safety advertisements.

21 October 1971

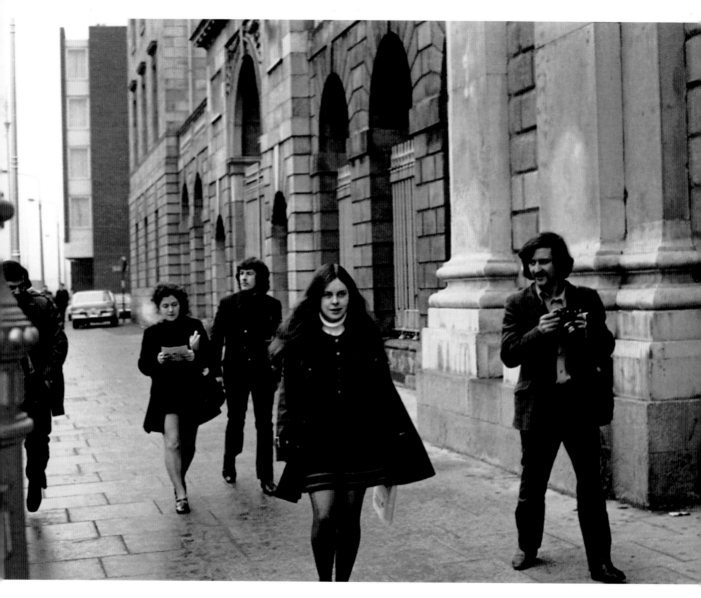

Bernadette Devlin arriving at the Four Courts as a defendant in a libel case. When she was elected as MP for Mid Ulster at the age of twenty-one, she was then the youngest member of parliament.

17 November 1971

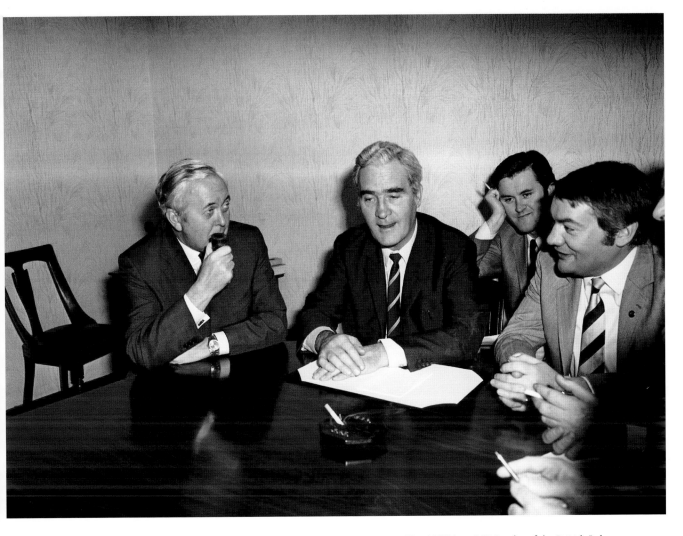

Harold Wilson MP, Leader of the British Labour Party, pays a courtesy call to his Irish counterpart, Brendan Corish, leader of the Irish Labour Party. Mr Corish was accompanied by several of his party colleagues. Picture shows (l to r) Harold Wilson, Brendan Corish, Michael O'Leary TD (in background) and Dr David Thornley TD.

2 December 1971

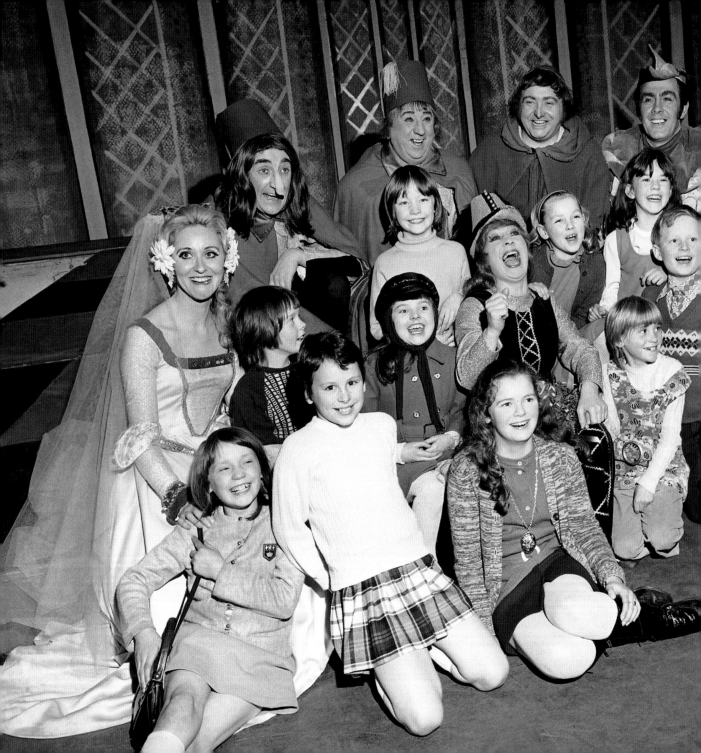

Maureen Potter (centre), and (l to r, back row)
Chris Curran, Danny Cummins, Eugene Lambert
and Austin Gaffney entertain Belfast children at the
Gaiety pantomime.

27 January 1972

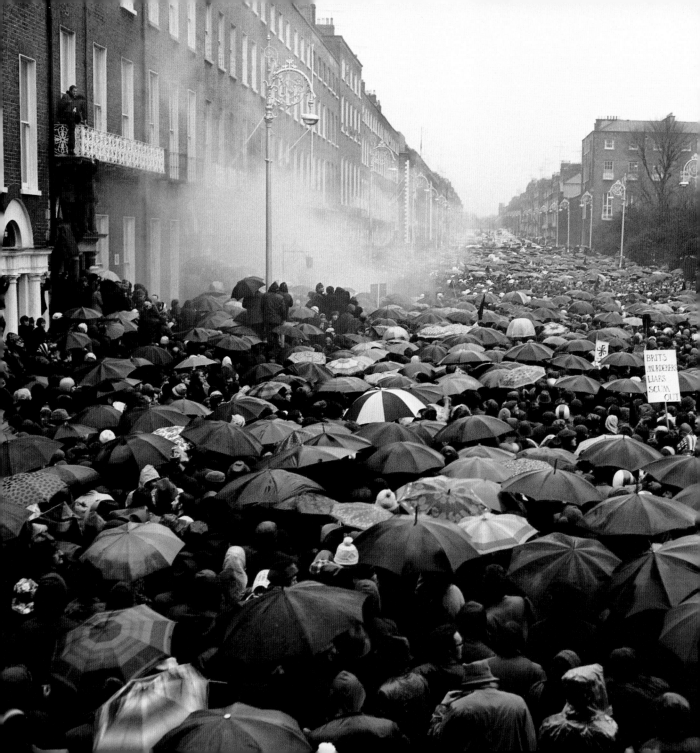

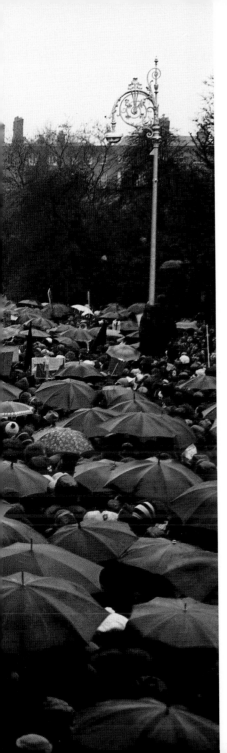

Tens of thousands marched on the British embassy in Merrion Square, Dublin, in protest at the Bloody Sunday killings of civil rights protesters in Derry by the Parachute Regiment on 30 January. The embassy was attacked by stones and petrol bombs before being set alight.

2 February 1972

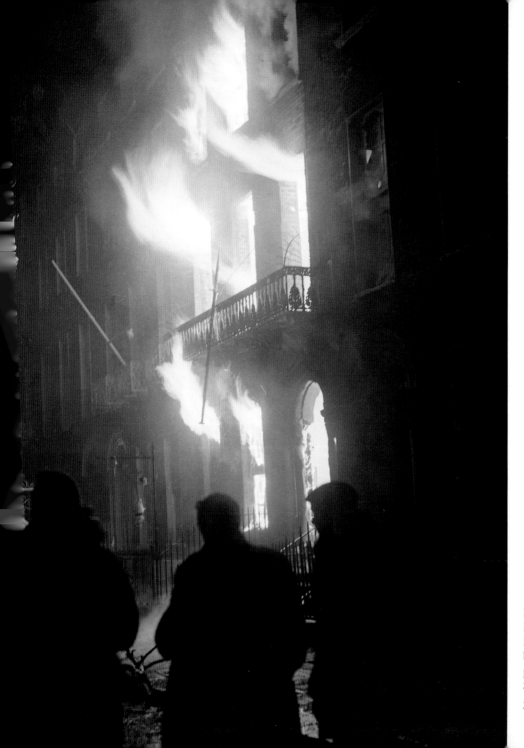

Flames engulf the British
Embassy building on
Merrion Square as it is
burnt to the ground in
protest at the Bloody
Sunday killings in Derry.

2 February 1972

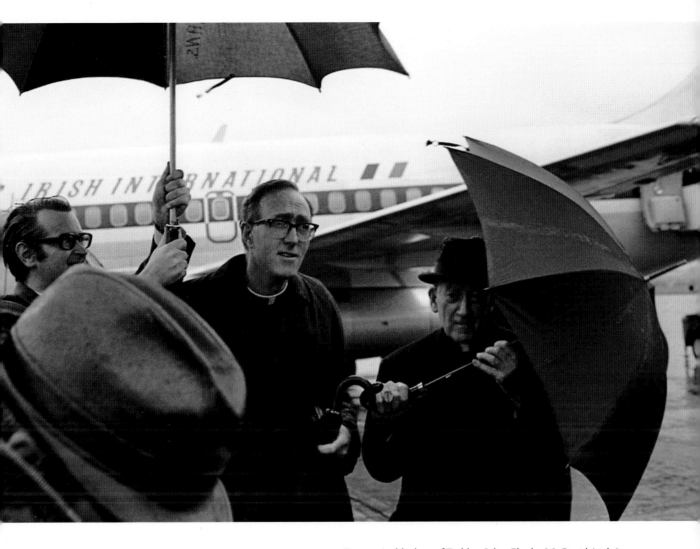

Former Archbishop of Dublin, John Charles McQuaid (right)
welcomes home his successor, Dermot Ryan (centre) on his return
from Rome following his official appointment as Archbishop of
Dublin by Pope Paul VI.

15 February 1972

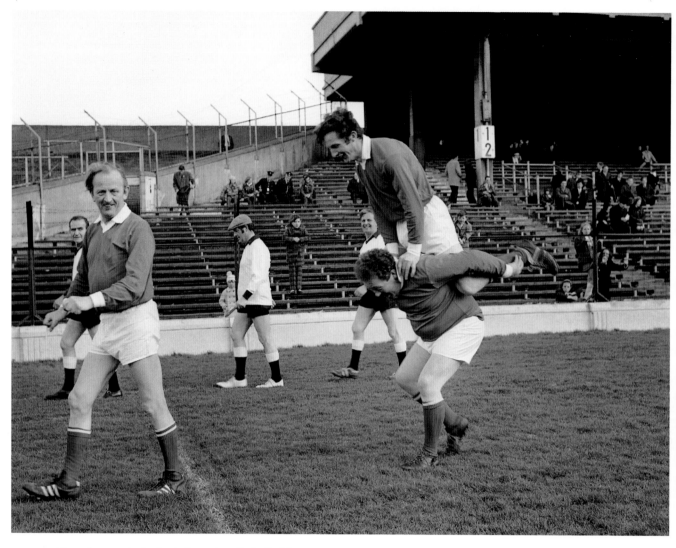

Horseplay at a charity football match at Croke Park between
TDs and Senators.

26 March 1972

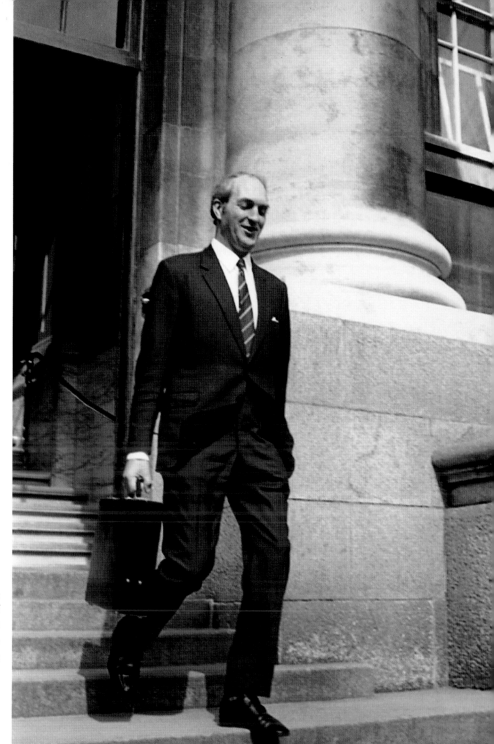

Minister for Finance, George Colley, leaving the Department of Finance on his way to Dáil Éireann to deliver his Budget speech.

19 April 1972

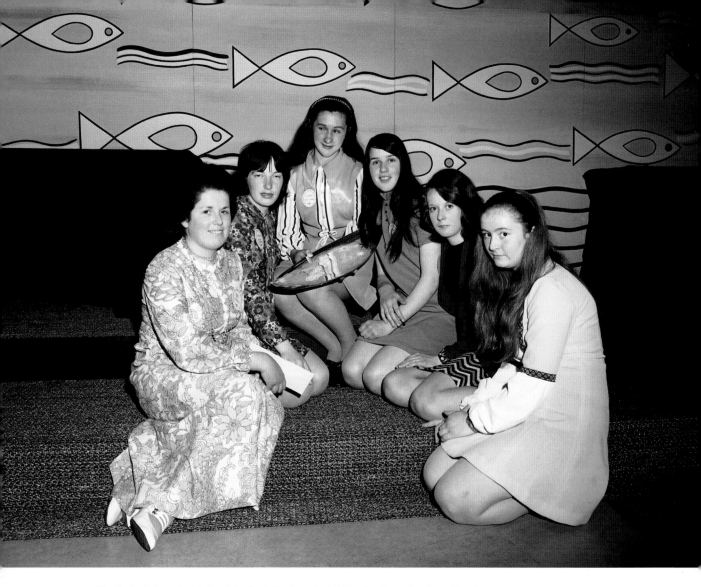

The final of the BIM National Seafood Cook 1972, held in the Great Southern Hotel, Killarney, Co Kerry. (l to r) Celine O'Reilly, Vocational School, Killucan, Co Westmeath, (2nd), Margaret McNamara, Convent of Mercy, Athlone, Co Westmeath, Mary Coleman (winner), Vocational School, Claremorris, Co Mayo, Eileen Fleming, Vocational School, Millstreet, Co Cork, Catherine Stapleton, Central Technical School, Kilkenny and Claire Gallery, St Patrick's Comprehensive School, Shannon, Co Clare.

4 May 1972

After a spate of accidents at sea where several fishermen drowned, Bord Iascaigh Mhara instituted a programme of swimming lessons for skippers and crews from around the country. Here, instructor Seamus Waters demonstrates the use of the float.

27 May 1972

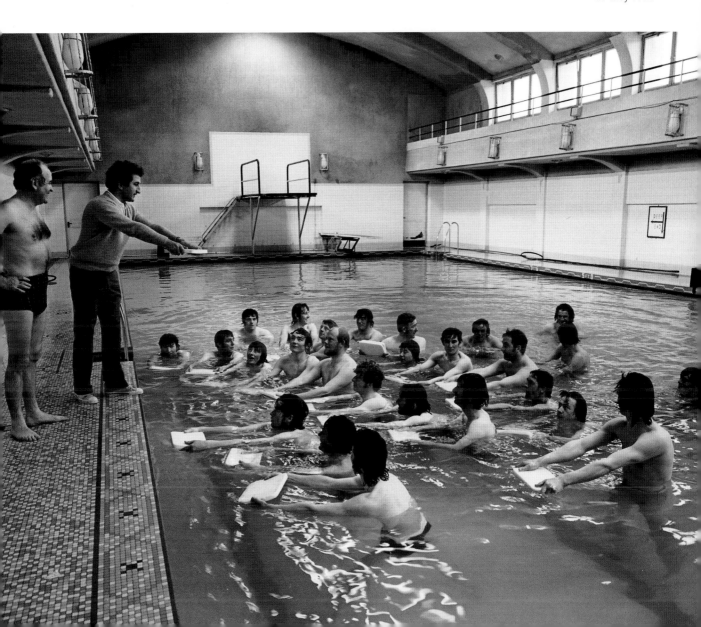

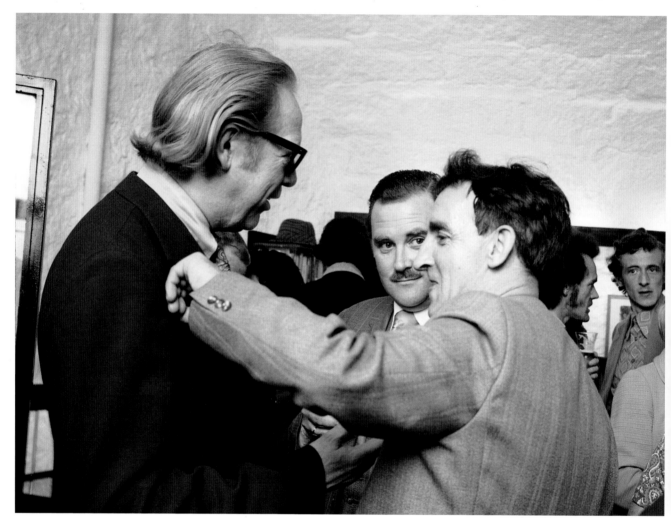

As part of the Bloomsday celebrations, Joyce's Tower, Sandycove was renovated and opened to the public. The tower is an important part of the novel *Ulysses*. Dominic Behan aims a playful punch at Professor Kevin Sullivan, Columbia University, watched by Proinsias Mac Aonghusa (centre).

16 June 1972

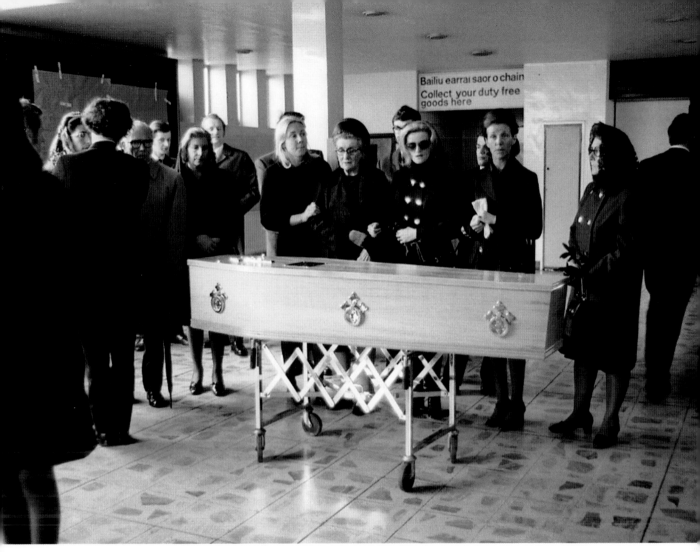

Twelve senior Irish businessmen on their way to Brussels were among 118 killed in the Staines air disaster on 18 June 1972. The coffin bearing the remains of one of the victims arrives back in Dublin airport to be received by family and friends.

22 June 1972

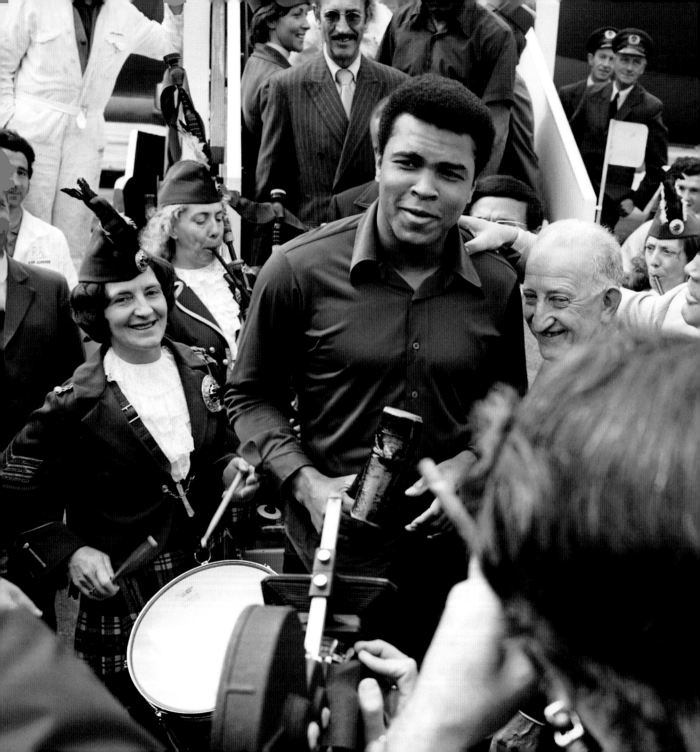

Muhammed Ali carries a shillelagh on his arrival in Ireland
in advance of his bout against Al 'Blue' Lewis at Croke Park
on 19 July. Ali won the fight with an 11th round knockout
in front of a crowd of 25,000 Irish fans.

11 July 1972

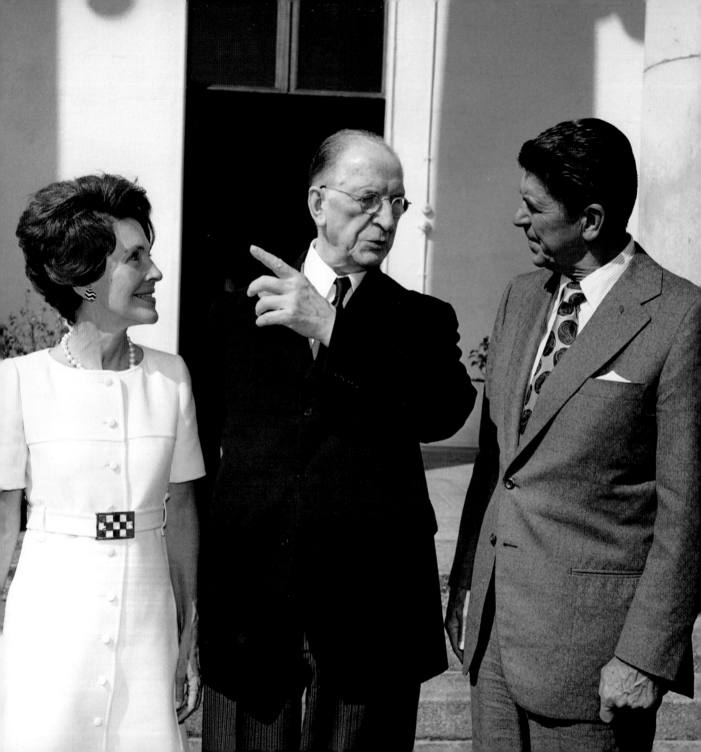

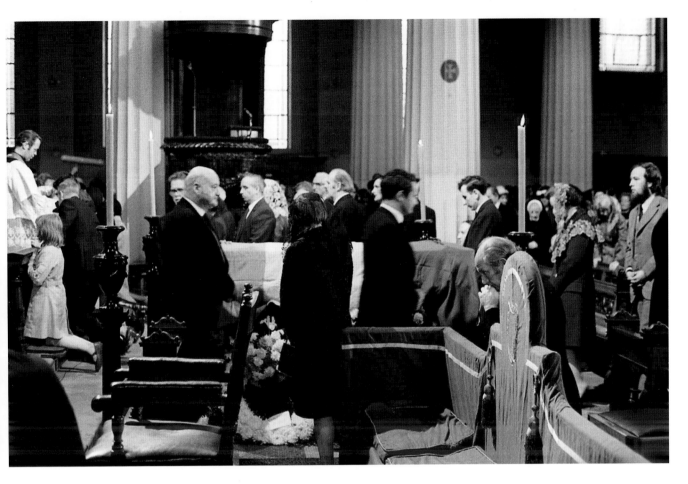

The State funeral of Kathleen Clarke, widow of executed 1916 leader Tom Clarke, in the Pro-Cathedral, Dublin. Kathleen Clarke was a founder member of Cumann na mBan, served as a senator 1928-36 and was the first female Lord Mayor of Dublin 1939-43. Her brother, Ned Daly was also executed in 1916. Pictured passing the coffin are Minister for Justice, Des O'Malley and Minister for Labour, Joe Brennan. An Taoiseach, Mr Jack Lynch, is kneeling to their right.

3 October 1972

Opposite
Governor Ronald Reagan of California and his wife, Nancy, are greeted at Áras an Uachtaráin by President de Valera.

18 July 1972

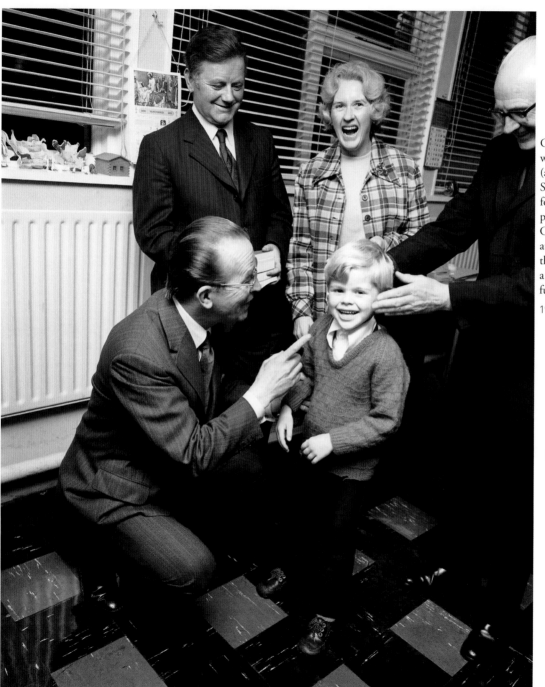

Comedian Jack Cruise with Brendan Coyne, (aged 5) a pupil of St Joseph's School for the Deaf. Cruise presented tickets for his Christmas pantomime at the Olympia to all those who took part in a charity walk to raise funds for the school.

19 November 1972

Opposite
Members of the Irish showjumping team including Paul Darragh (2nd left), and Lt Col Billy Ringrose (right).

28 November 1972

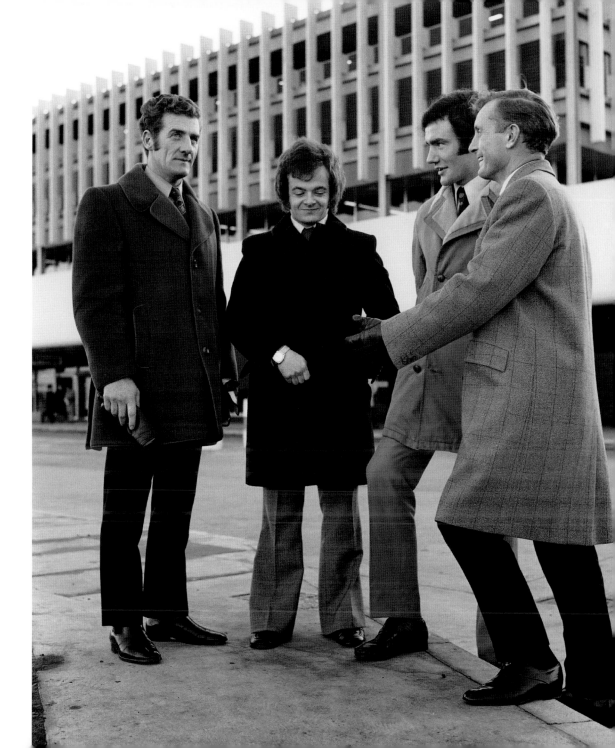

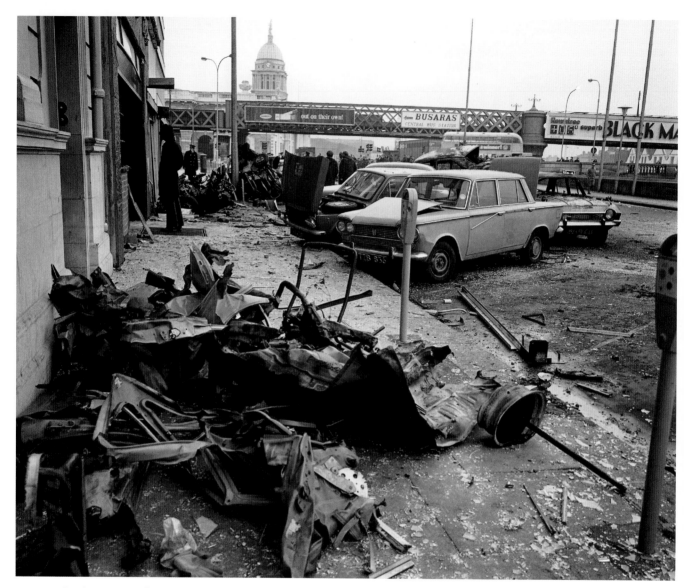

On the morning of 2nd December two car bombs exploded in Dublin City. At Sackville Place, busmen George Bradshaw (30) and Thomas Duffy (23) were killed as they waited in their car to resume work. The bomb was thought to be planted by a Northern Ireland subversive group who hoped to influence legislation going through Dáil Éireann in relation to the IRA. The remains of the car used as the bomb vehicle lie scattered on the pavement along Eden Quay.

2 December 1972

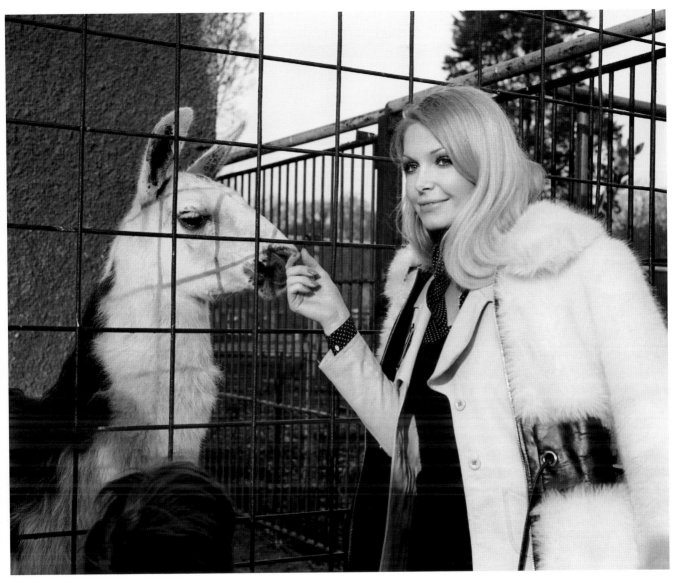

Miss Eva Rueber-Staier, former Miss World from Austria and the World Wildlife Fund's 'Anniversary Girl', pets a llama during her visit to Dublin Zoo.

14 January 1973

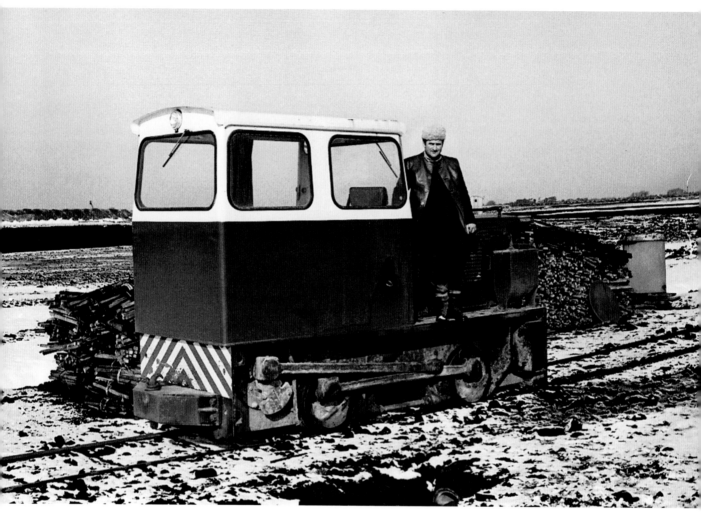

A snowy scene from the Bord na Mona works at
Littleton, County Tipperary.

19 February 1973

Opposite

Liam Cosgrave watches as the votes are counted in the general election. After
sixteen consecutive years of Fianna Fáil government the Irish people went to
the polls to elect a new government. Cosgrave is hopeful that a coalition with
Labour would oust the existing office holders.

28 February 1973

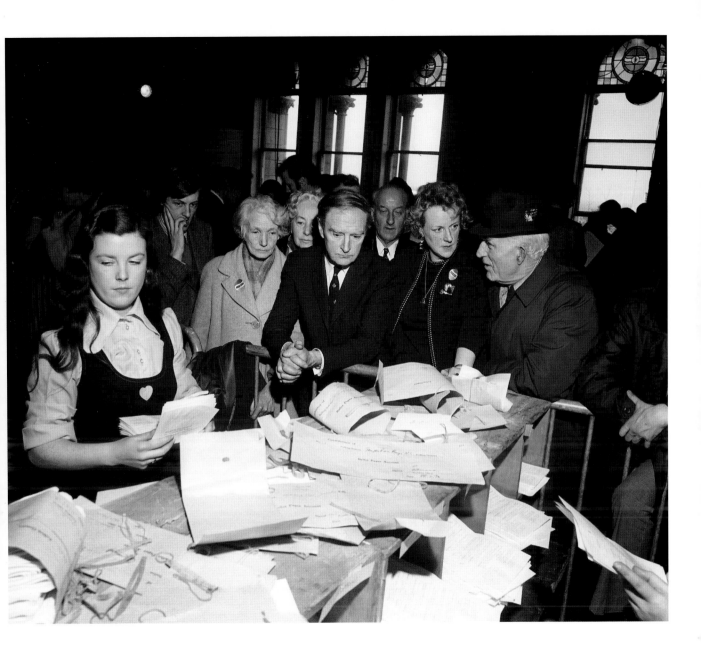

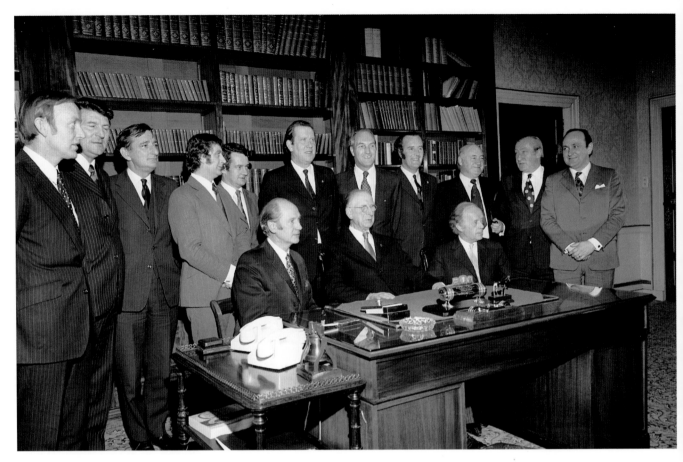

The outgoing Fianna Fáil Cabinet with President de Valera. On either side of the President are Jack Lynch (left) and Erskine Childers (right). Standing (l to r) are Michael O'Kennedy, Gerry Cronin, Jim Gibbons, Bobby Molloy, Des O'Malley, Padraig Faulkner, George Colley, Paddy Lawlor, Joe Brennan, Sean Flanagan and Gerry Collins.

14 March 1973

Opposite

The incoming Fine Gael/Labour Cabinet. Seated (l to r) Mark Clinton (Agriculture and Fisheries); James Tully (Local Government); An Taoiseach, Liam Cosgrave; An Tanaiste, Brendan Corish (Health & Social Welfare); Patrick Donegan (Defence); Richie Ryan (Finance). Standing (l to r) Patrick Cooney (Justice); Tom Fitzpatrick (Lands); Tom O'Donnell (Gaeltacht); Peter Barry (Transport & Power); Conor Cruise O'Brien (Posts & Telegraphs); Richard Burke (Education); Garrett FitzGerald (Foreign Affairs); Michael O'Leary (Labour); Declan Costello, Attorney-General; Justin Keating (Industry & Commerce).

14 March 1973

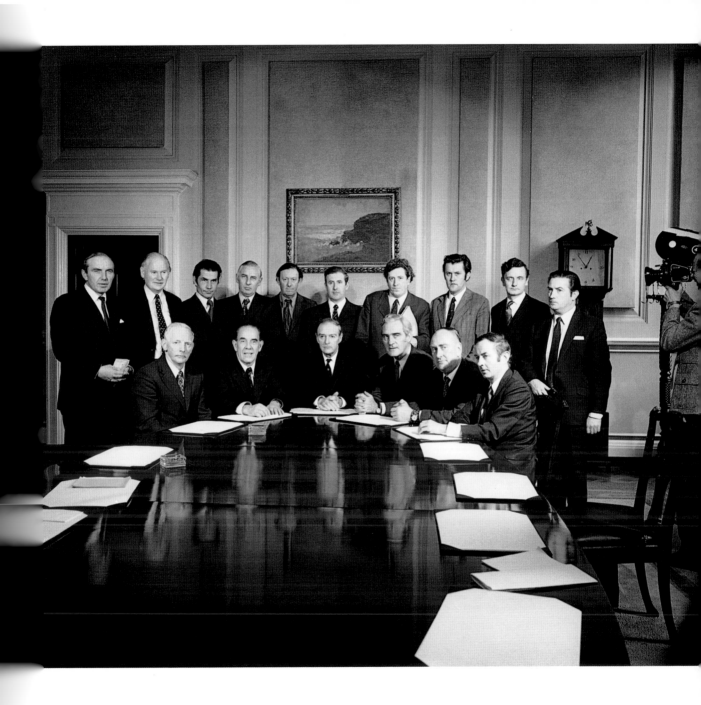

59

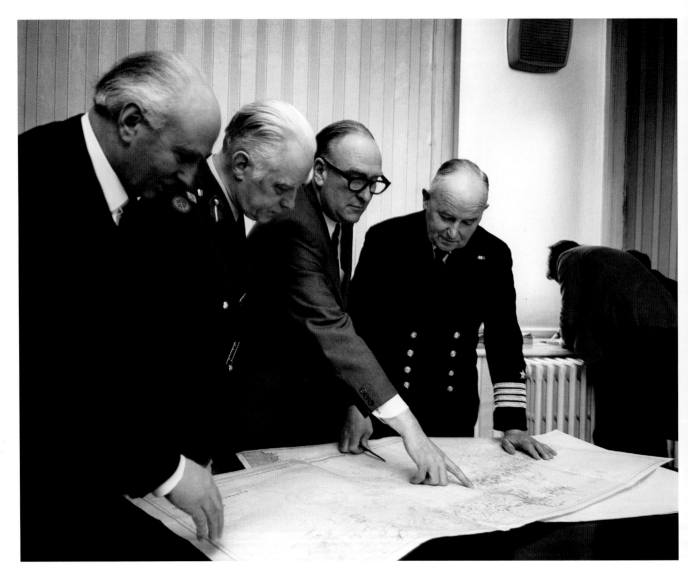

Paddy Donegan, TD, Minister for Defence (centre, wearing glasses) indicating on the map where five tonnes of arms and ammunition from Libya, bound for the IRA, had been found on the ship *Claudia*, when it was intercepted near Helvick Head, Co Waterford. Also in the picture are members of the Naval Service and the Army.

29 March 1973

Abbey actors leave for a tour of Finland
and the USSR. Well-known faces include
John Kavanagh and Eamon Morrissey.

15 May 1973

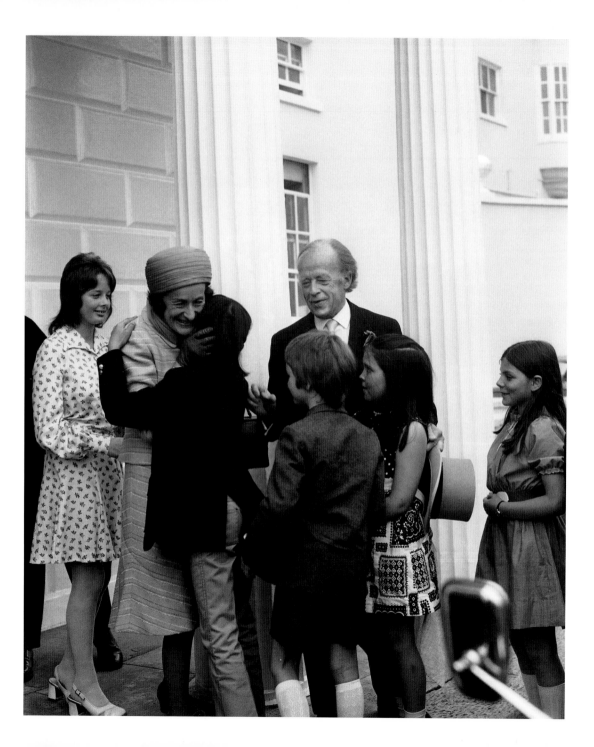

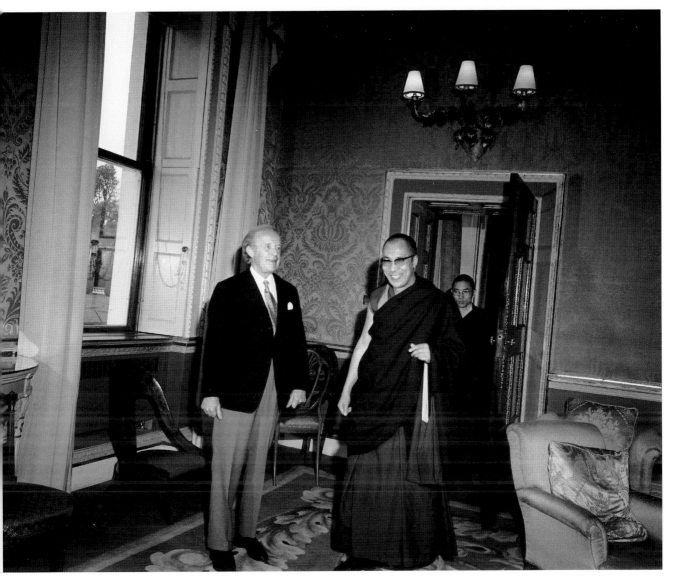

Opposite
Newly inaugurated President Erskine Childers and his wife, Rita, are congratulated by grandchildren at the Áras. The couple's daughter, Nessa, is on the extreme left of the picture.

25 June 1973

President Childers receives the Dalai Lama at Áras an Uachtaráin.

10 October 1973

Angler Brendan O'Dowd displays the first salmon
caught this year. Brendan's friend and Mr Ted Moynihan
proudly hold the salmon up for the cameraman.

2 January 1974

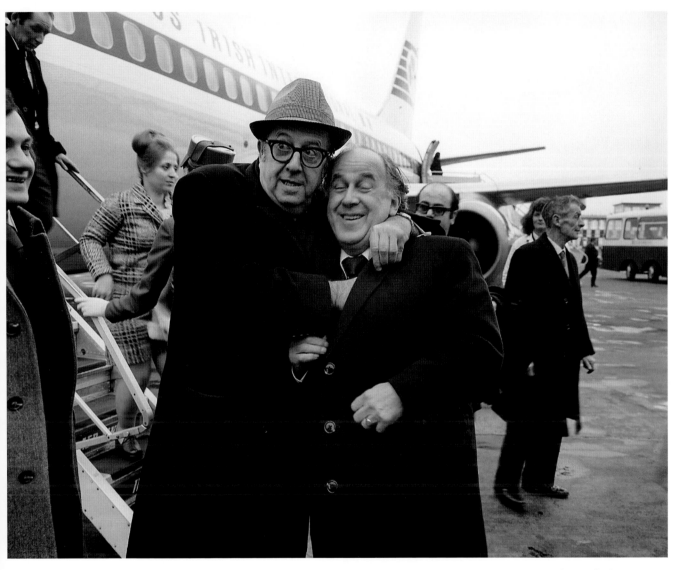

American comedian and actor Phil Silvers, most famous for his role as 'Sergeant Bilko' in the TV series, checks out the pockets of Joe Kearns, Manager of the Gaiety Theatre, on his arrival to star in 'A Funny Thing Happened To Me on the Way to the Forum'.

9 March 1974

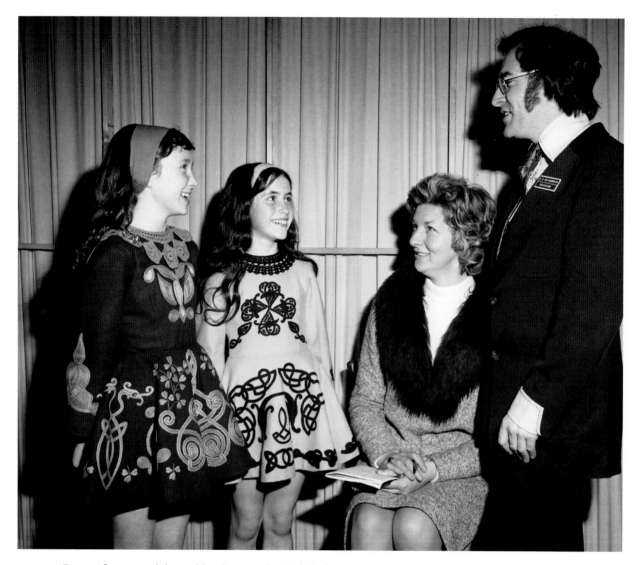

Dancers from around the world took part in the World Irish Dancing Competition at the Mansion House, Dublin. Pictured are (l-r) Sheila Hayes, O'Regan School of Dance, Cork, Catherine Cuthbert, Cullinane School of Dance, Cork, Ms Phyllis O'Brien, teacher at the O'Regan School and Dr John Cullinane, Organising Commissioner of the championships.

11 April 1974

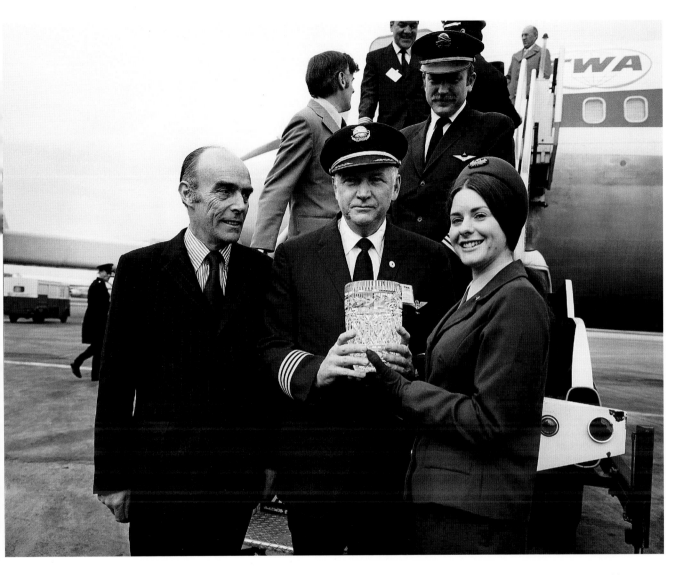

The first direct flight to Dublin from the USA was operated by TWA (Trans World Airways) with a Boeing 707. Miss T Bergin, Carlow, (Aer Rianta) presented the captain with a crystal vase. Included in the picture is Mr Liam Boyd, Manager in Ireland for TWA.

2 May 1974

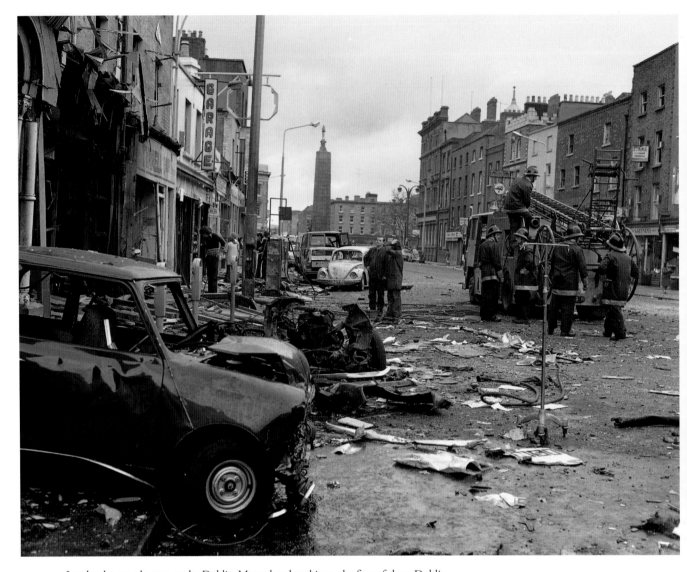

In what became known as the Dublin-Monaghan bombings, the first of three Dublin car bombs went off at approximately 17:28 in Parnell Street; the second went off at approximately 17:30 in Talbot Street, and the third a few minutes later in South Leinster Street near the railings of Trinity College. The Monaghan bomb exploded some 90 minutes later. This is the scene in Parnell Street.

17 May 1974

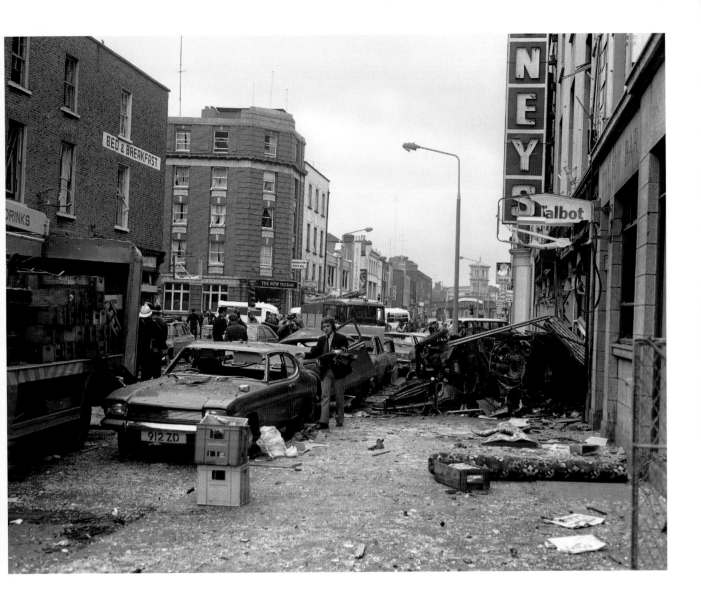

The clear-up begins in Talbot Street in the aftermath of the bomb. The attacks killed 33 civilians – 26 in Dublin and 7 in Monaghan – and wounded almost 300, the highest number of casualties in any one day during the Troubles.

17 May 1974

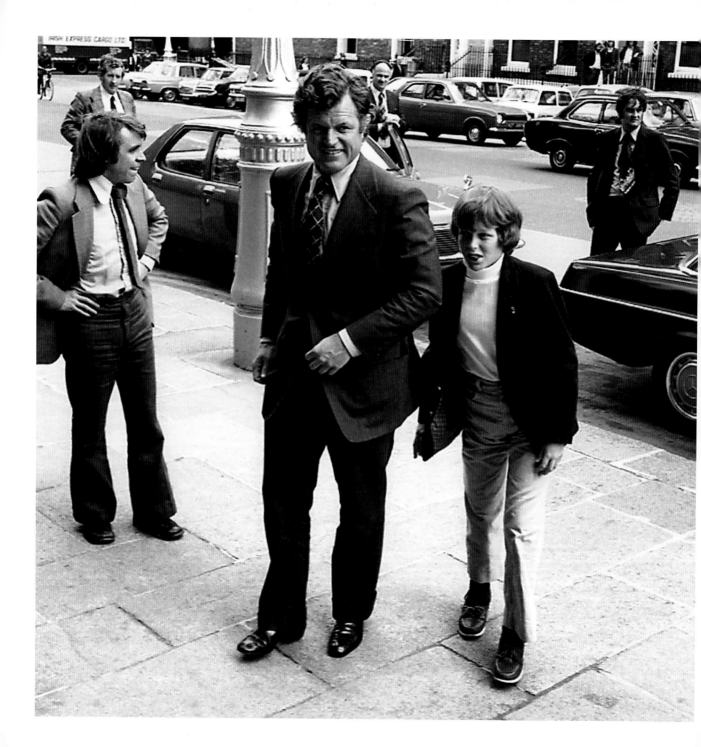

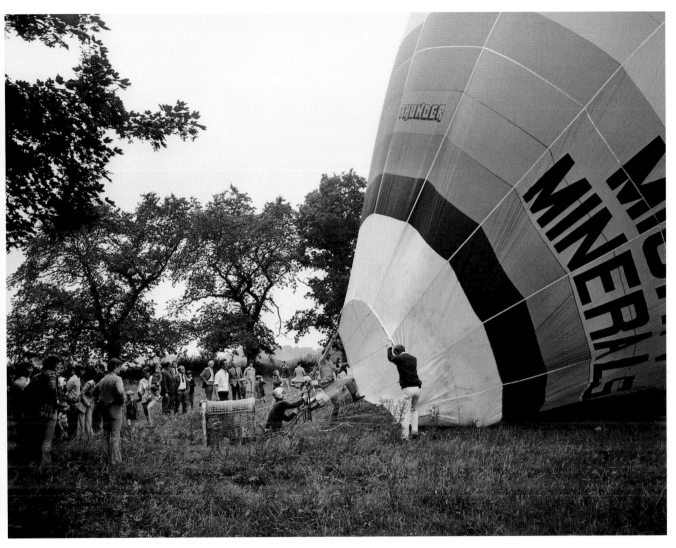

Opposite
Edward Kennedy and his son pay a courtesy visit to Government Buildings.

June 1974

Crowds watch as the Dew Mighty Minerals hot air balloon prepares to launch, as part of the Tullamore Festival Week. The balloon was piloted by Mr Wilf Woollett, a veterinary surgeon from Loughrea, Co Galway and his co-pilot was Kevin Haugh.

7 August 1974

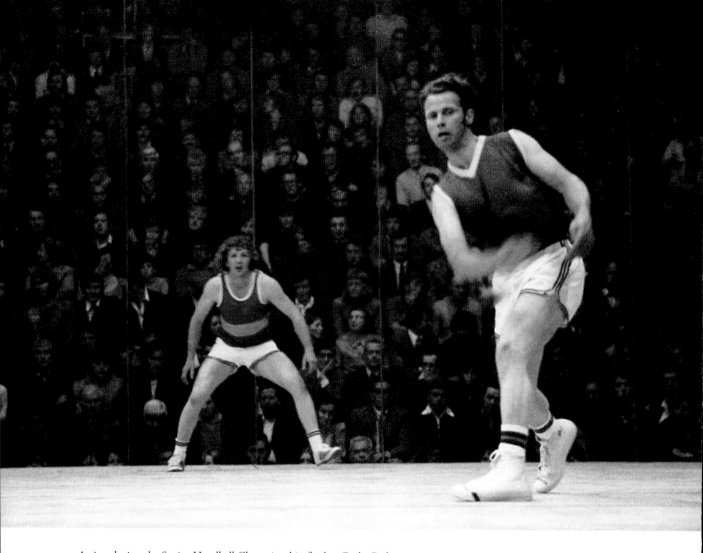

Action during the Senior Handball Championship final at Croke Park.
The final was contested between Pat Kirby of Ennis, Co Clare and Pat
Murphy of Wexford (in hooped shirt). Murphy was the eventual winner.

31 August 1974

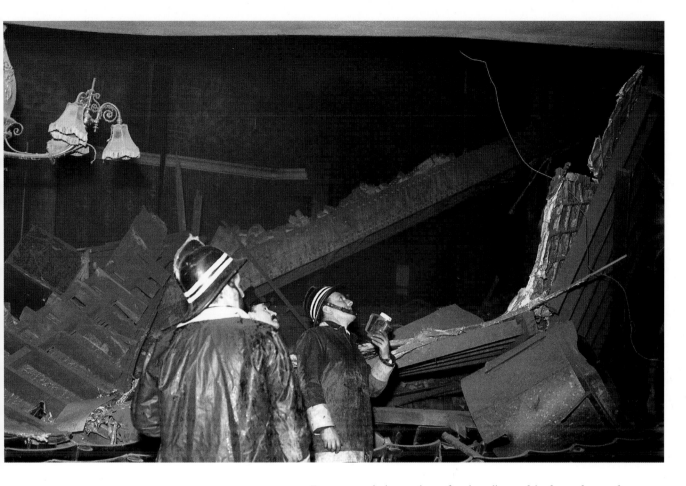

Firemen search the wreckage after the collapse of the front of stage of the Olympia Theatre. The collapse happened during lunch break of the rehearsal of 'West Side Story', due to open that night.

5 November 1974

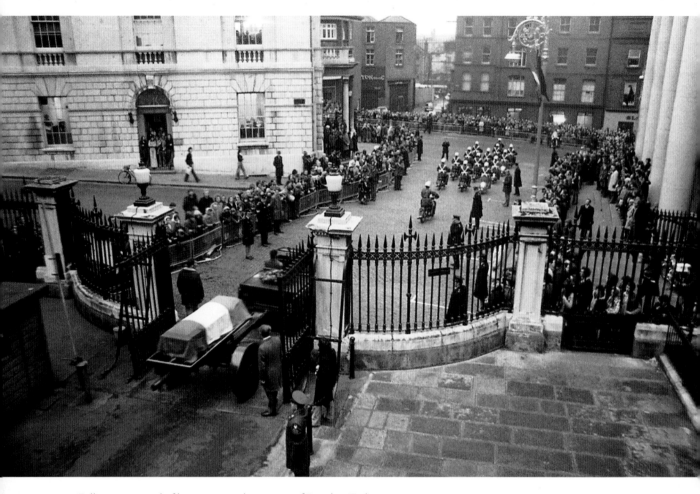

Following a period of lying in state, the remains of President Erskine Childers are removed from Dublin Castle for the funeral service at St Patrick's Cathedral. He had been in office since June 1973 and collapsed after making a speech to the Royal College of Physicians.

20 November 1974

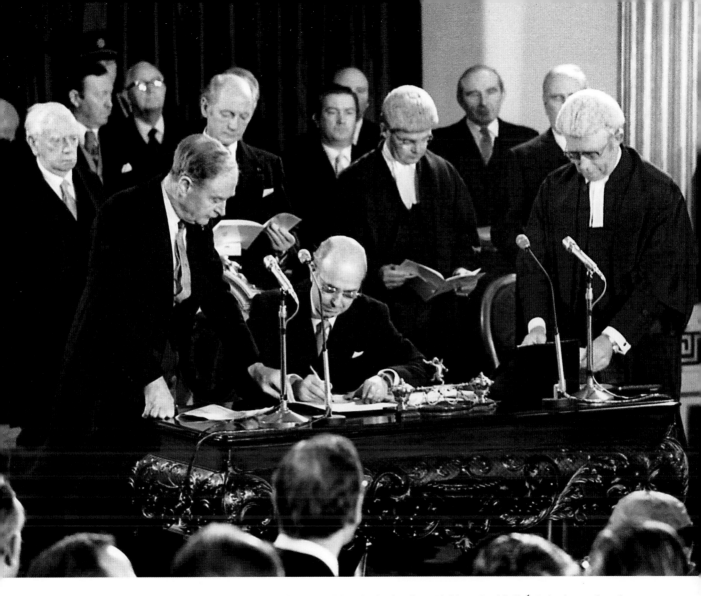

After the sudden death of Erskine Childers, Cearbhall Ó Dálaigh was elected unopposed as fifth President of Ireland. Here, watched by Taoiseach Liam Cosgrave and Chief Justice Tom O' Higgins, he signs the oath of office.

19 December 1974

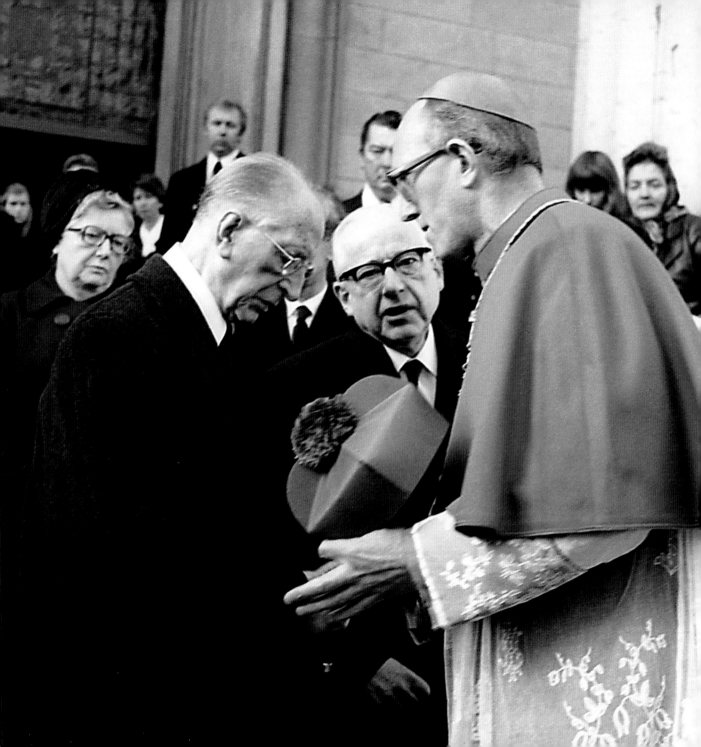

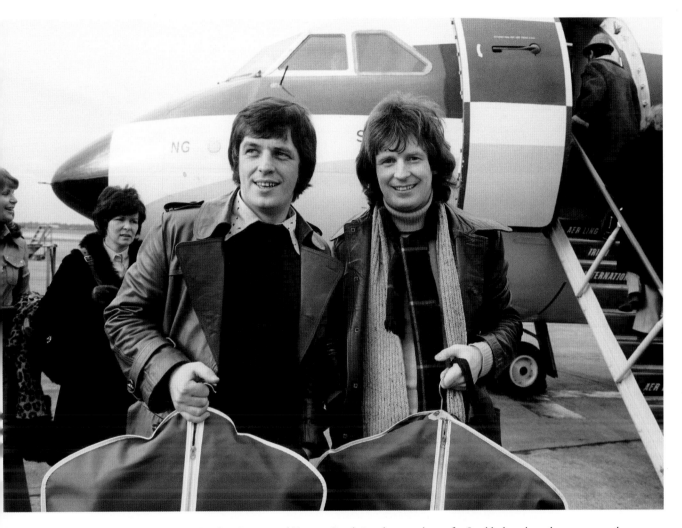

Brothers Jimmy and Tommy Swarbrigg about to depart for Stockholm where they represented
Ireland in the Eurovision Song Contest. Their song, 'That's What Friends Are For' came 9th in the
competition, which was won by the Netherlands' entry, 'Ding-a-Dong'.

18 March 1975

Opposite
Eamon de Valera is consoled by the Archbishop of Dublin, Dermot Ryan, after the funeral
Mass for his wife, Sinead, in the Pro-Cathedral. Born in 1878, Sinead Bean de Valera
wrote many books for children, in English and in Irish, including books of Irish fairy tales.

9 January 1975

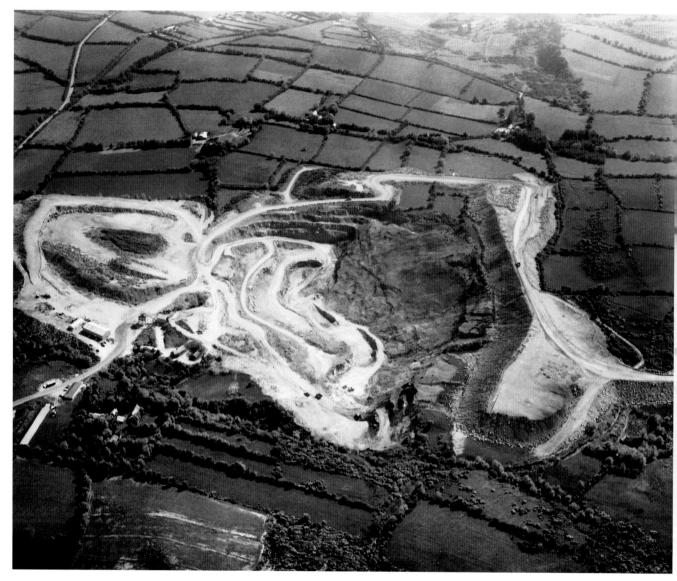

An aerial view of Silvermines, Co Tipperary where mining has been going on intermittently over the centuries. Opencast mining of barytes began in 1963 and lead and zinc were also discovered. This was worked underground from 1968 to 1982 by Mogul of Ireland Ltd. The mine closed in 1992.

17 May 1975

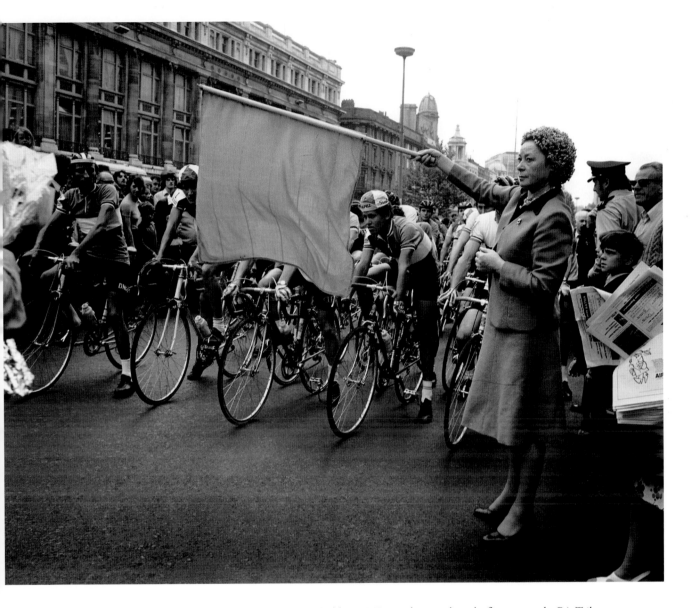

Actress Siobhan McKenna about to drop the flag to start the Rás Tailteann.
The cycle race, which covers 900 miles around Ireland, would finish in
Limerick on 12 June. A field of seventy-seven riders were listed to take part.

7 June 1975

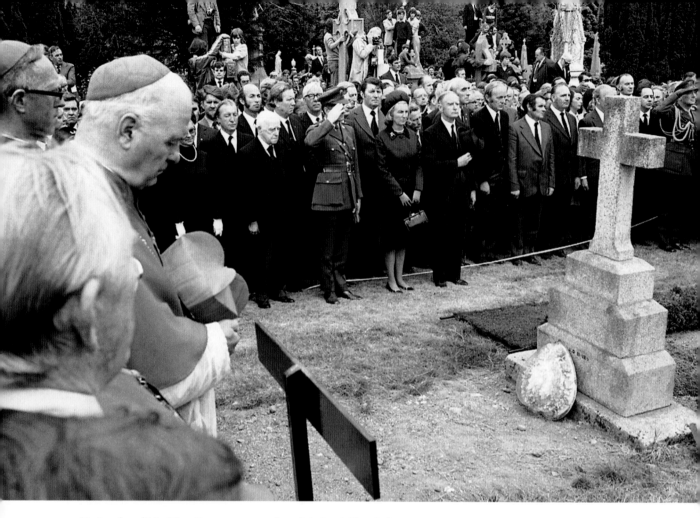

Taoiseach and Mrs Liam Cosgrave among the political and Church dignatories
at the graveside of Eamon de Valera as he is buried in Glasnevin cemetery. A
founder of Fianna Fáil, he served several terms as Taoiseach, then became the
third President of Ireland in 1959, re-elected in 1966. At his retirement in 1973
at the age of 90, he was the oldest head of state in the world.

2 September 1975

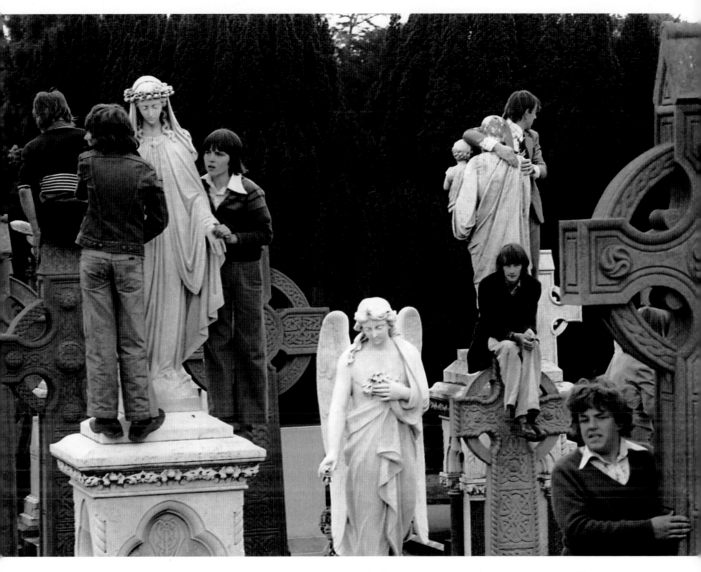

Onlookers trying to get the best vantage point in Glasnevin cemetery to view the burial of Eamon de Valera.

2 September 1975

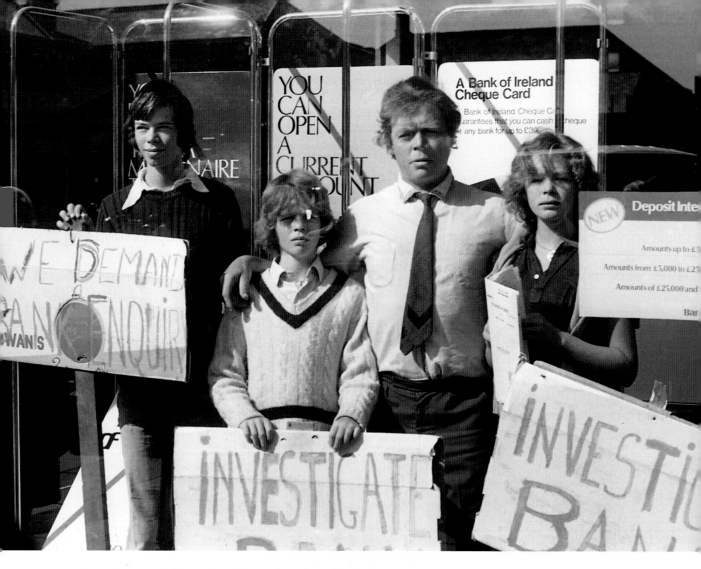

Fergus Rowan, a Dublin seed merchant, and members of his family stage a sit-in at Bank of Ireland HQ in Westmoreland Street. Following the 1970 bank strike the family business found itself in financial difficulties, having accepted cheques in good faith, which were declined by the bank, as 'dodgy'. The business was eventually put into receivership.

22 August 1975

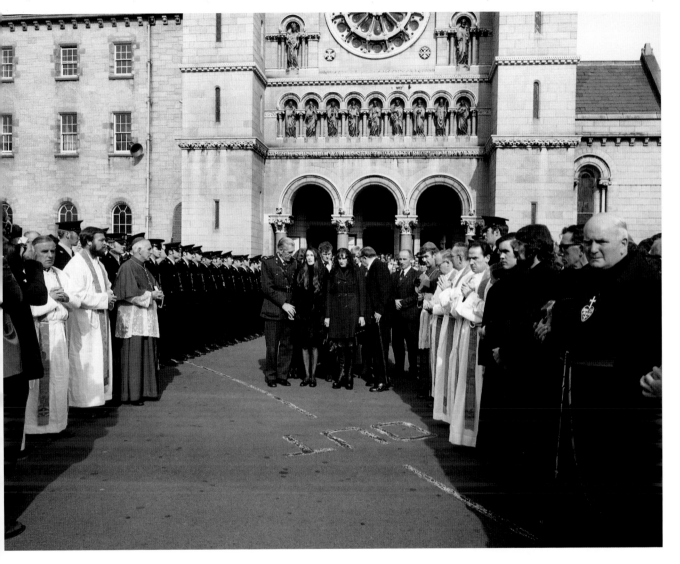

The funeral of Garda Michael Reynolds leaves St Paul's Church, Mount Argus, after requiem Mass. Superintendent Tom Goulding escorts his widow, Mrs Vera Reynolds and sister, Kathleen Reynolds. Garda Reynolds was shot dead as he pursued a gang of bank robbers. Noel and Marie Murray were convicted of his capital murder and sentenced to death, subsequently commuted to life imprisonment.

13 September 1975

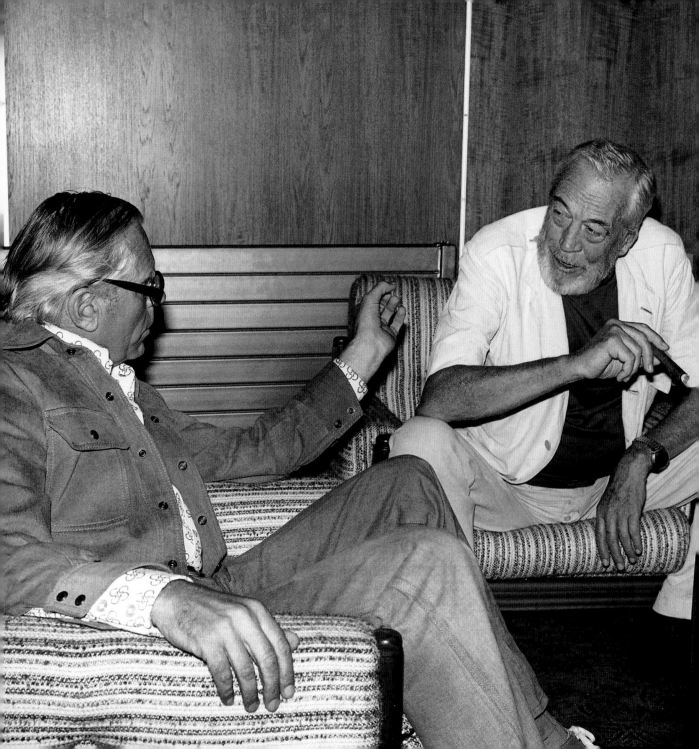

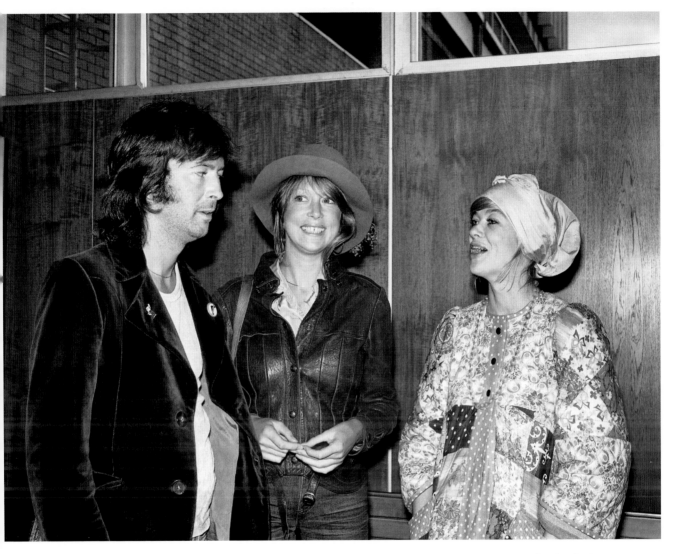

(l to r) Eric Clapton, Patti Boyd and Judy Geeson
arrive to take part in 'Circasia 75'.

13 September 1975

Opposite
Renowned film director John Huston (right) flies in from Mexico to take part
in 'Circasia 75' at Straffan House, Co Kildare, where he is to play the part of
ringmaster. He is pictured with Kevin McClory, organizer of the event.

13 September 1975

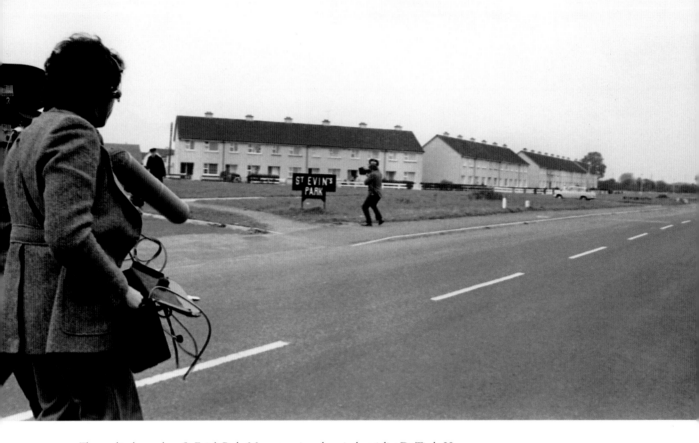

The media descend on St Evin's Park, Monasterevin, where industrialist Dr Tiede Herrema of Ferenka was being held hostage by Eddie Gallagher and Marion Coyle. Dr Herrema was kidnapped on 3 October, but it was only now that his location was established. A two-week siege followed before the kidnappers surrendered and he was released.

21 October 1975

At a press conference before his return to Holland, Dr Herrema holds up the bullet given to him by his captor, Eddie Gallagher, who told him: 'This was meant for you'. To his left (partly obscured) is his wife, Elizabeth.

8 November 1975

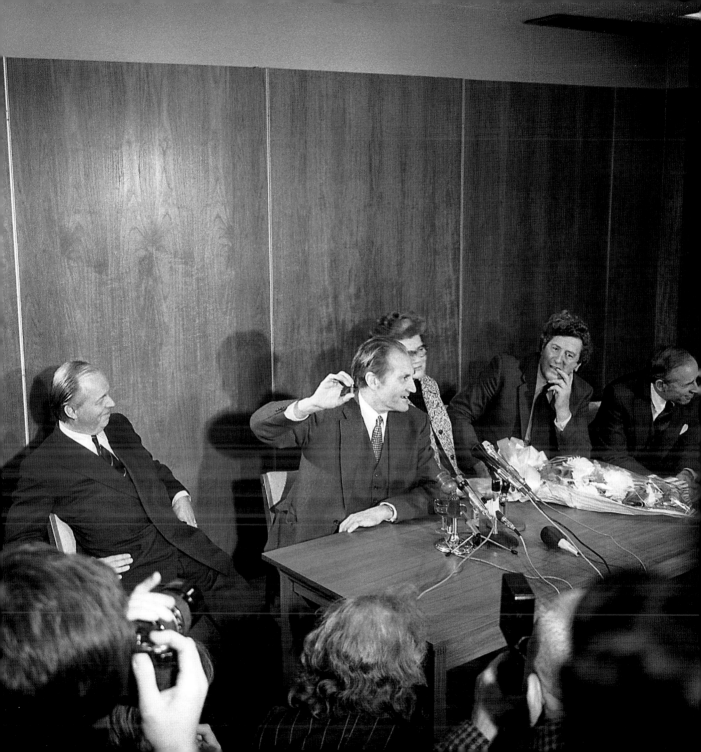

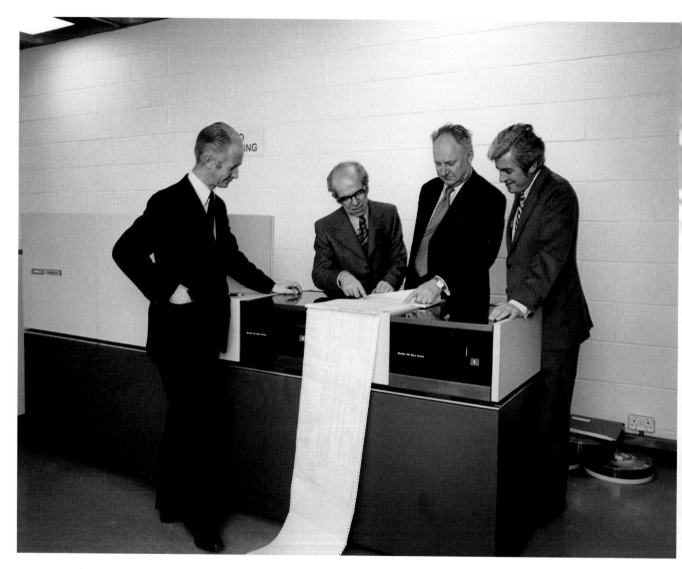

A Singer System 10 computer is installed in the Faculty of Commerce in University College Dublin, (U.C.D.). The computer would be used by graduate and post graduate students at the university. Pictured at the official handover were, (l-r), Professor M J McCormac, Dean, Faculty of Commerce, Professor Denis McConalogue, Professor of Computer Science, Dr Thomas Murphy, President, U.C.D. and Mr Michael McMahon, Regional Director for Ireland, Singer Business machines.

29 October 1975

Actors Shirley MacLaine and Burgess Meredith on a visit to Ireland. MacLaine has had a long and successful career, being nominated five times for an Academy Award before winning for her role in 'Terms of Endearment'. Actor and director Meredith had numerous film and television roles, including a much-acclaimed portrayal of The Penguin in the TV series of 'Batman'. He received a Tony Award nomination for his 1974 Broadway staging of 'Ulysses in Nighttown'.

17 June 1975

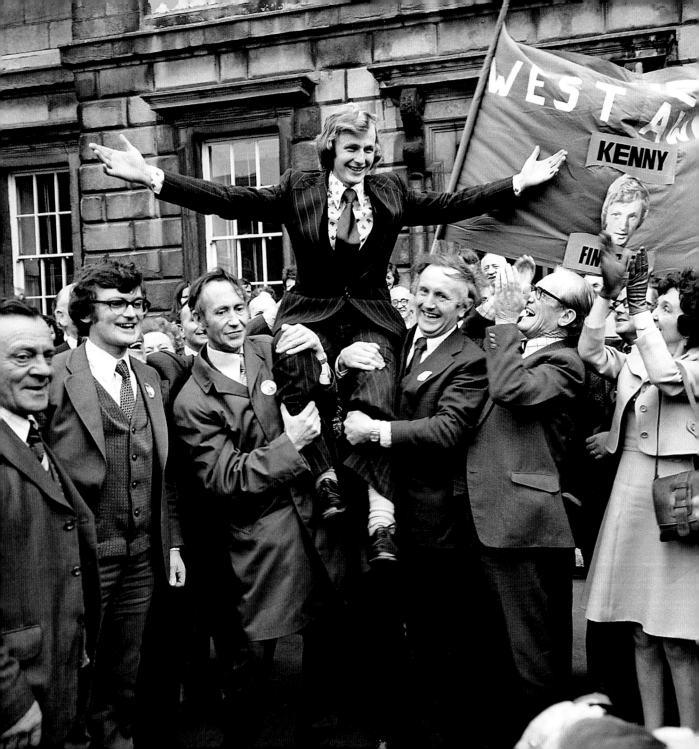

The West's Awake! Supporters carry the new Fine Gael Deputy for West Mayo, Enda Kenny, shoulder-high on his first day in Dáil Éireann. Enda Kenny would become Taoiseach in 2011.

18 November 1975

In 1975 Ardmore Studios was renamed The National Film Studios of Ireland, with Seamus Smith as managing director and film director John Boorman as chairman. Pictured at the opening are (l to r) Seamus Smith, Justin Keating, Minister for Industry and Commerce, and John Boorman. The studios hosted several major films including 'The Purple Taxi' and 'The Great Train Robbery'.

20 November 1975

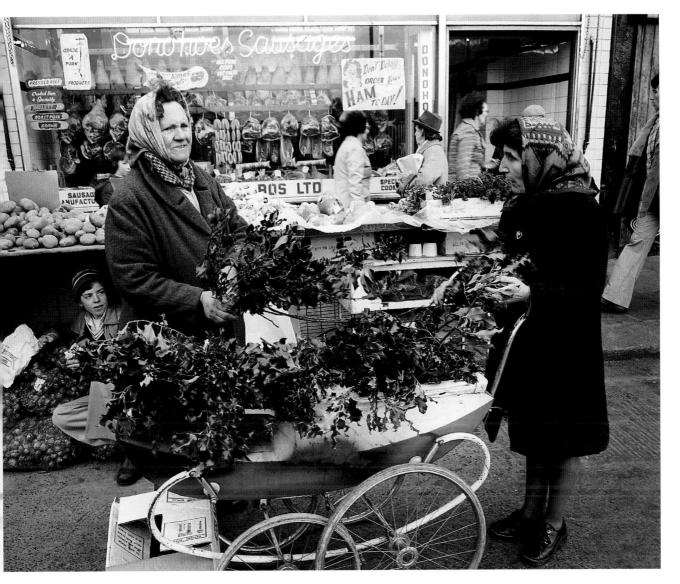

Moore Street traders prepare bunches of holly for
Christmas, while under the table a boy sits beside nets
of Brussels sprouts and Christmas hams hang in the
butcher's shop window.

20 December 1975

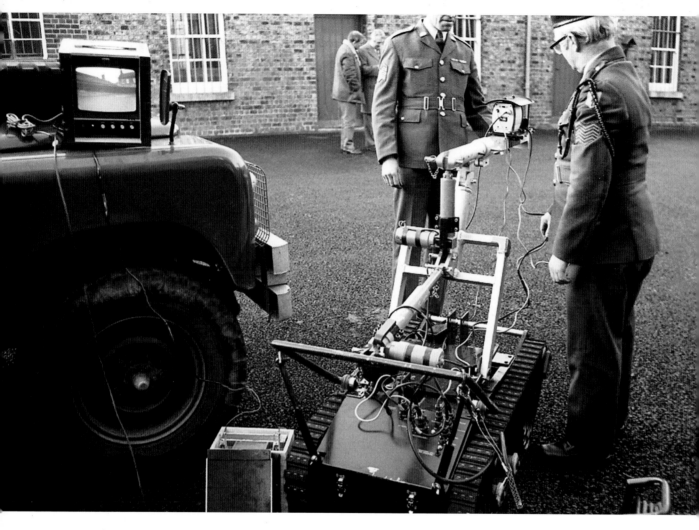

At Clancy Barracks, Dublin, the Irish army displays its
newly acquired Remote Controlled Vehicle to be used
for bomb disposal.

29 December 1975

Opposite
Grainne Cosgrave tries out the artificial dry ski slope
created at the Kilternan Golf and Country Club.
Aspiring skiers could learn the basics or improve
techniques before embarking on a skiing holiday.

25 January 1976

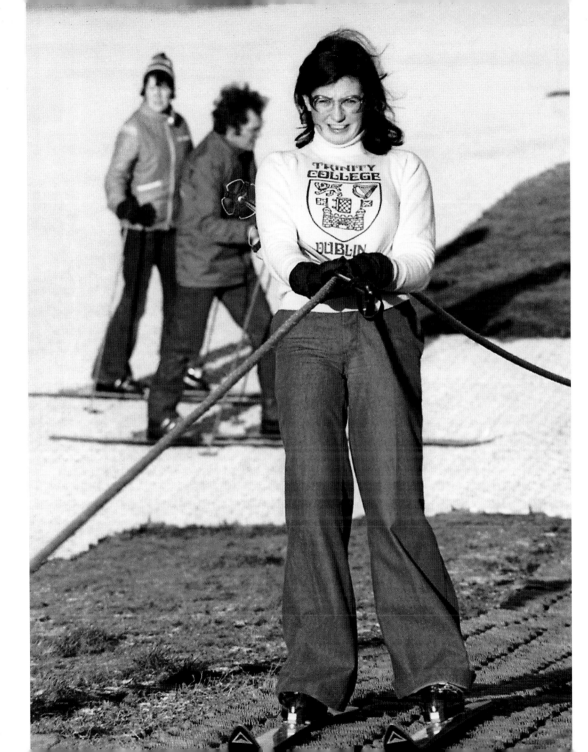

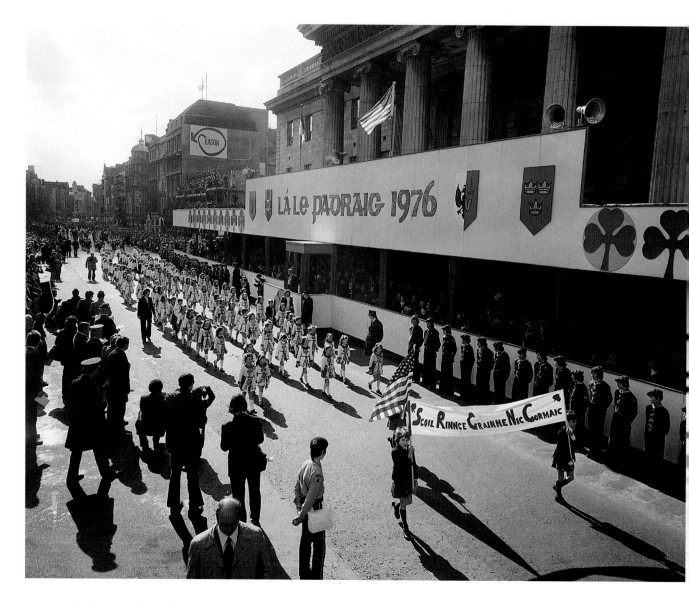

Pupils of Scoil Rince Grainne Nic Cormaic pass the
reviewing stand at the Saint Patrick's Day Parade.

17 March 1976

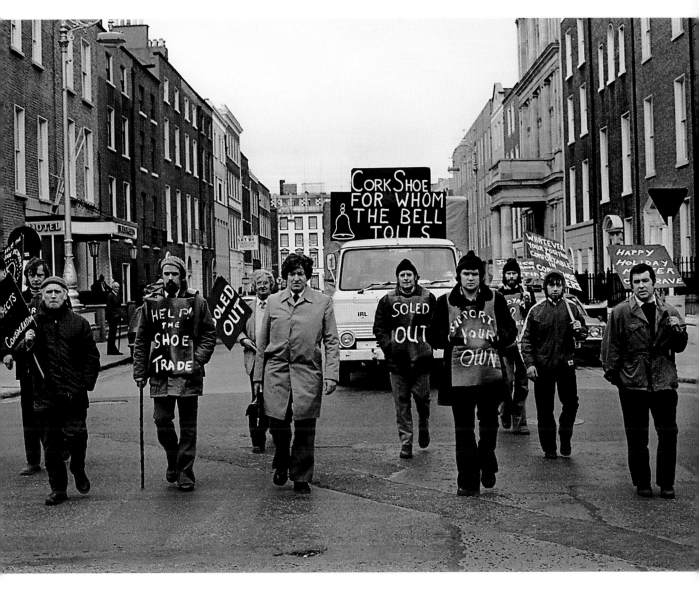

Workers from the Cork Shoe Co Ltd walked from Cork to
meet their TDs at Leinster House, in protest at the closure
of their factory.

24 March 1976

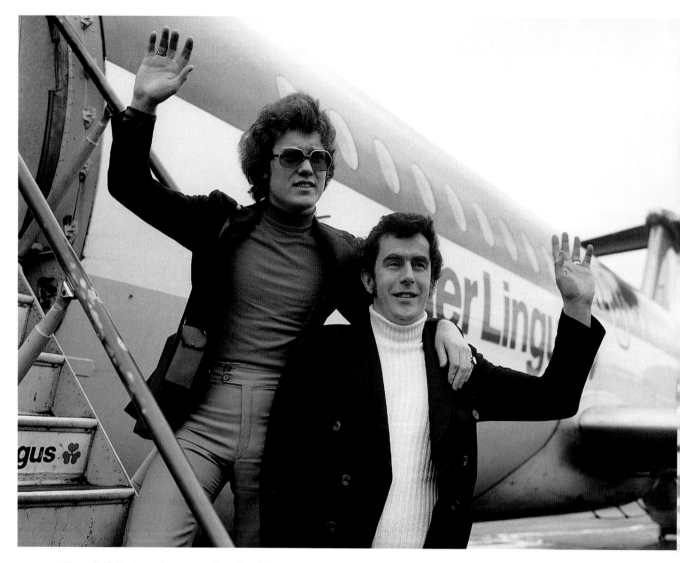

Singer Red Hurley and composer Brendan Graham head off for the Eurovision Song Contest in The Hague. The song 'When' came 10th in the contest, which was won by Brotherhood of Man with 'Save Your Kisses for Me'.

30 March 1976

Opposite
The sail training vessel 'Creidne' leaves Dun Laoghaire harbour to take part in transatlantic races organised to coincide with the American Bicentennial celebrations.

15 April 1976

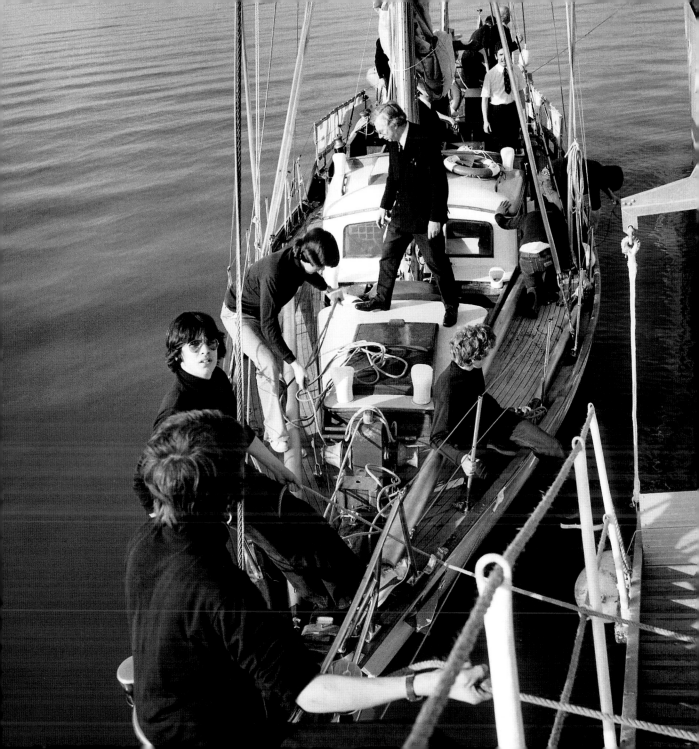

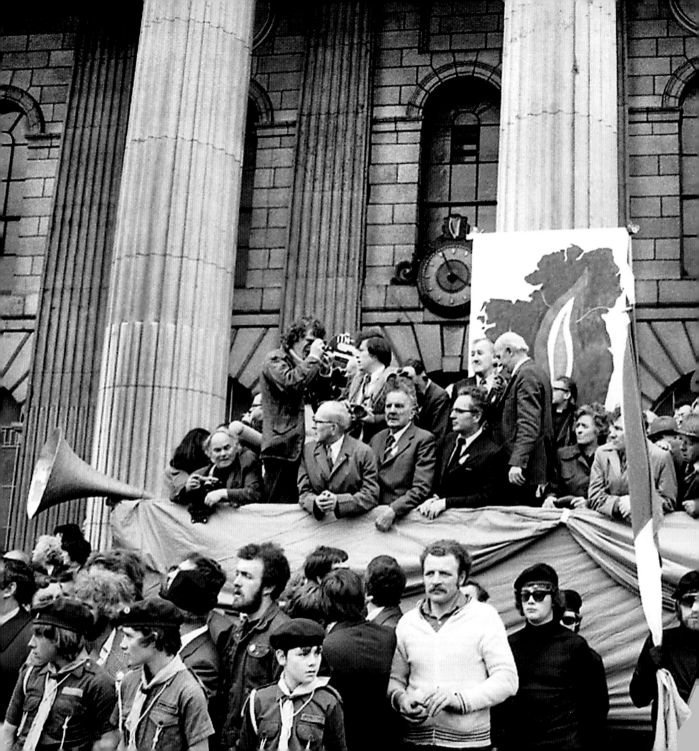

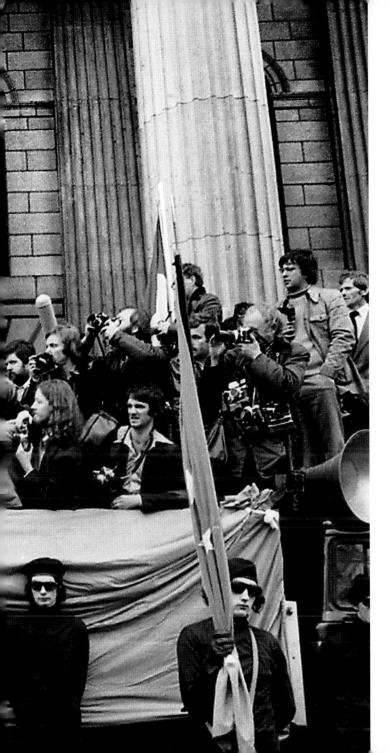

Sinn Féin march to commemorate the Easter Rising 1916. Among those on the reviewing platform at the GPO are President of Sinn Féin, Ruairi Ó Bradaigh (fourth from left, wearing glasses) and, to his left, Máire Drumm, Vice President, Sinn Féin.

25 April 1976

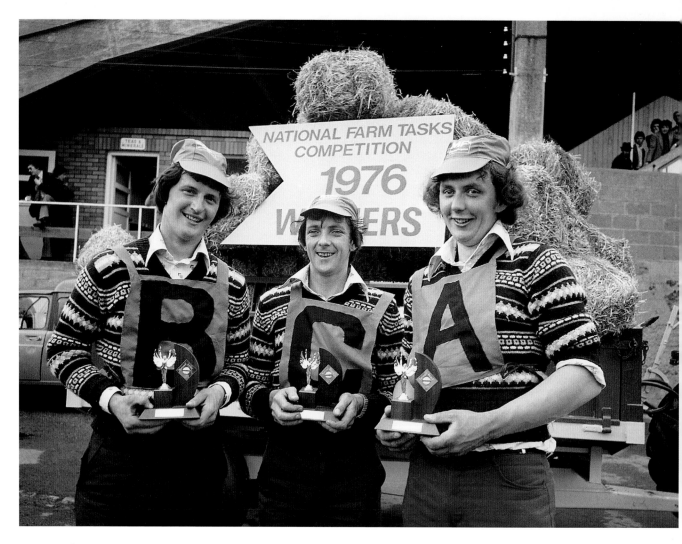

The victorious Tullyallen, Co Louth Macra na Feirme team, Pat Winters,
George O'Brien and Gerry Healy, display their trophies after they were
declared overall winners of the National Farm Tasks Competition,
sponsored by Irish Shell Ltd. Over 400 teams originally took part in the
competition.

7 May 1976

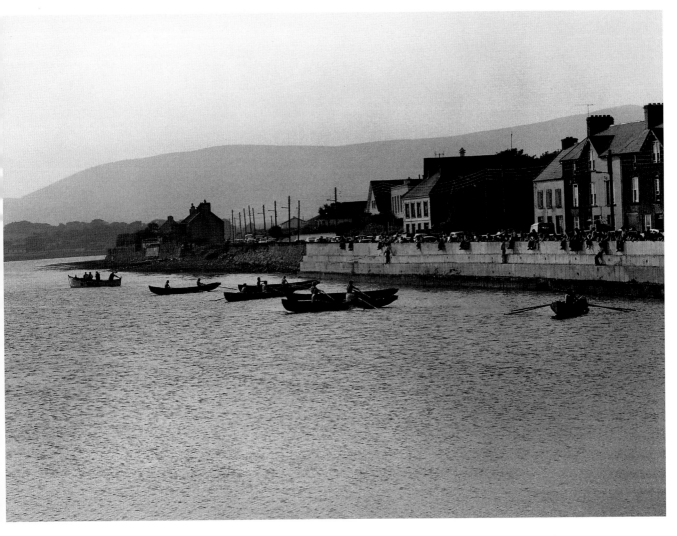

A line-up of currachs at the start of the Seine Boat
Competition at the Dingle Regatta.

22 August 1976

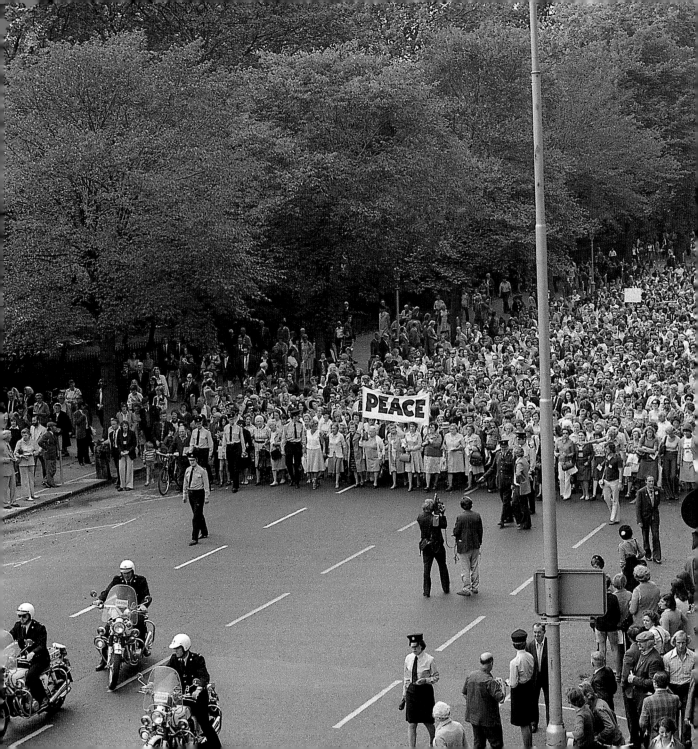

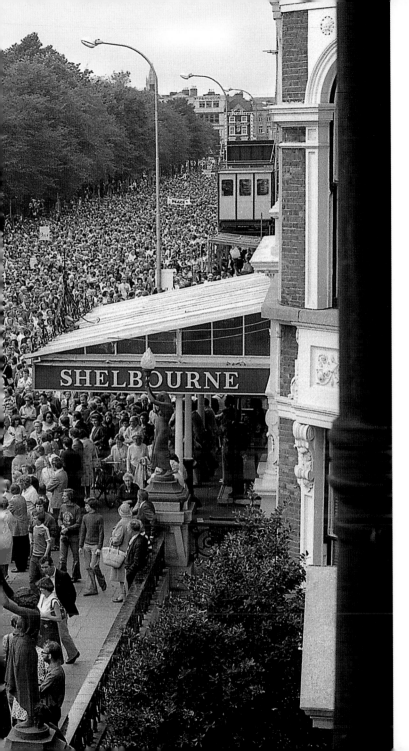

Thousands took part in the Women's Peace March, organised as part of the Peace Movement set up by Betty Williams and Mairead Maguire in Northern Ireland. The march went from St Stephen's Green to Leinster House, to plead for peace and an end to the continuing violence in Northern Ireland.

28 August 1976

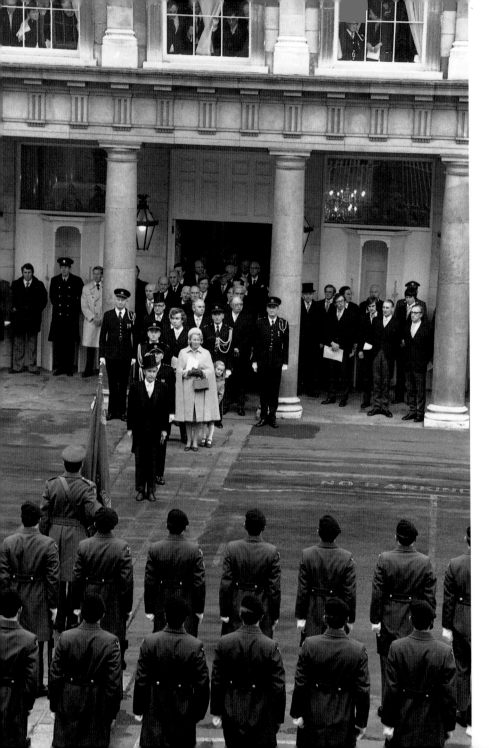

President Hillery, his wife Maeve, son John and daughter Vivienne leave Dublin Castle after his inauguration as sixth President of Ireland.

3 December 1976

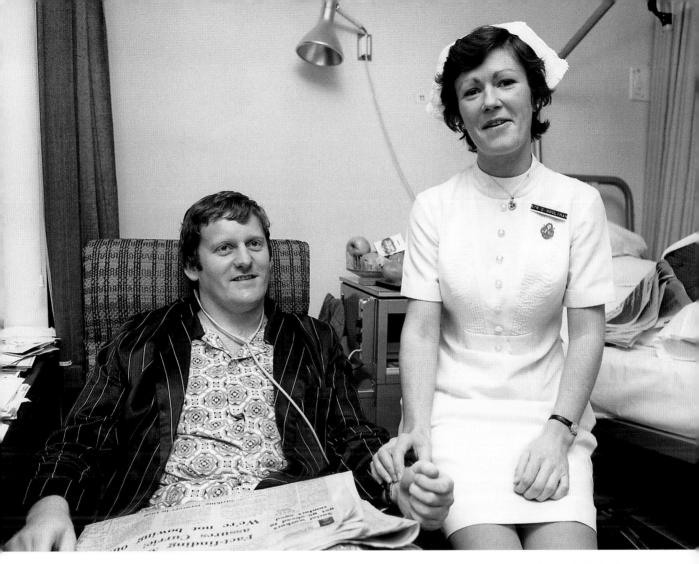

Following a training ground accident at the Ireland team trial, rugby international Barry McGann was admitted to St Vincent's Nursing Home, Merrion Road, Dublin, for treatment and recuperation. Taking his pulse is Staff Nurse C Houlihan.

13 January 1977

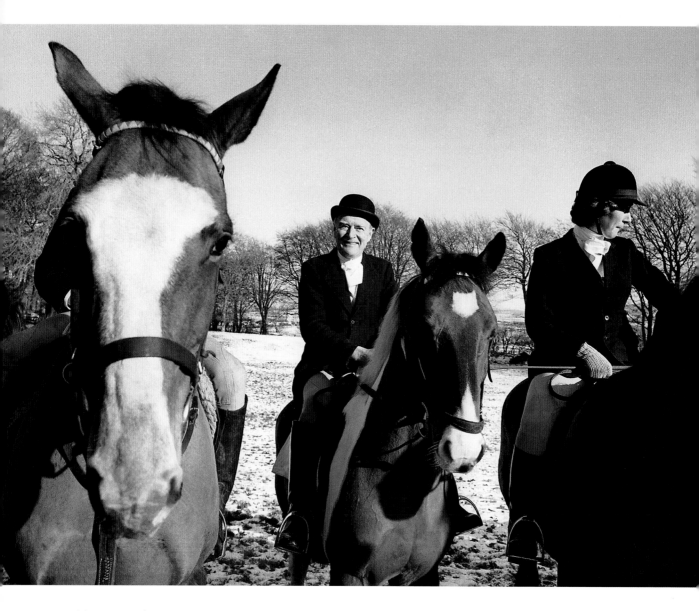

The New Year hunt meet at Brittas, Co Dublin.
Taoiseach Liam Cosgrave and others prepare to set out
from Brittas Lodge in snowy conditions.

29 January 1977

Opposite
A prizewinner in the Friesan Bull
category at the RDS Bull Show.

1 March 1977

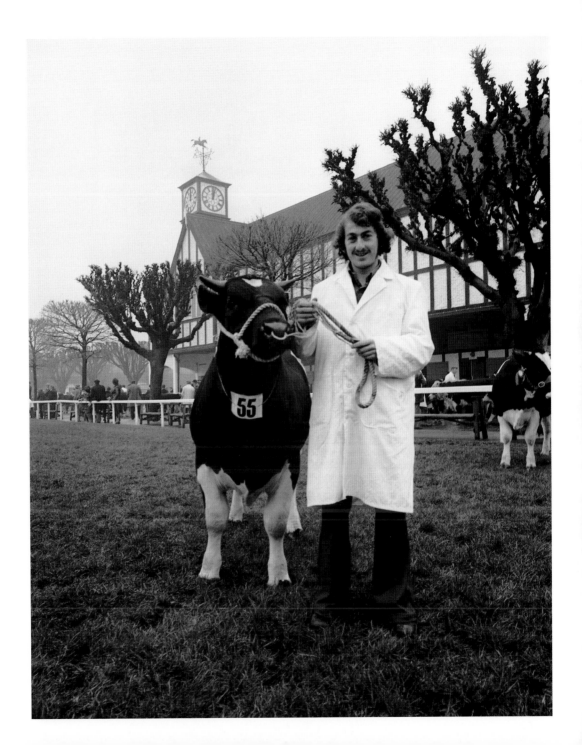

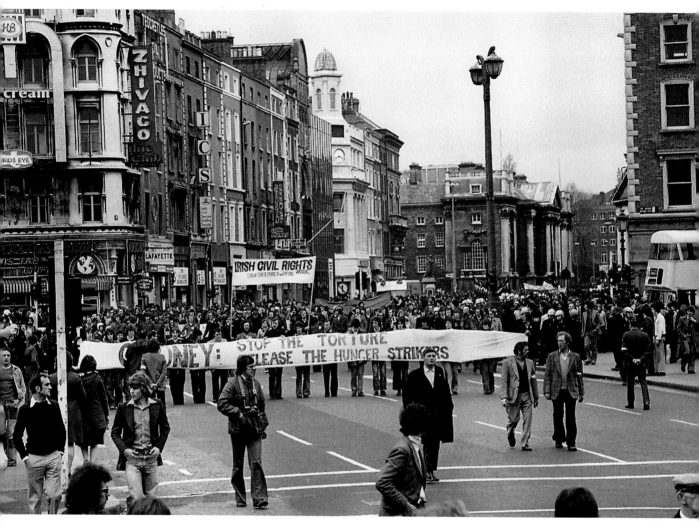

A section of the crowd who marched to the GPO in support of the Portlaoise hunger strikers.

16 April 1977

Opposite
Sean Duffy wears his Irish Volunteer uniform for the last time before presenting it to the National Museum, Kildare Street, Dublin. He wore the uniform on active service in the North Brunswick/North King Street theatre of operations in Easter Week 1916. He also managed to wear it while in detention in both England and Wales in the aftermath of the Rising.

23 April 1977

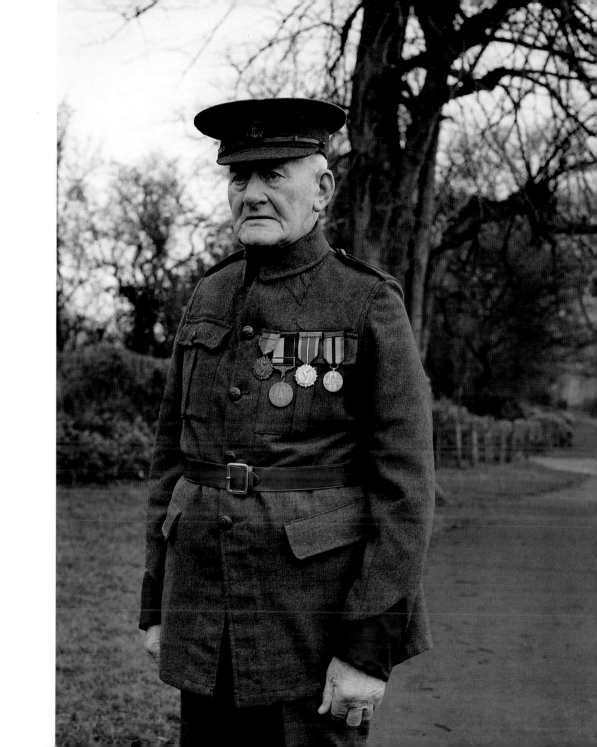

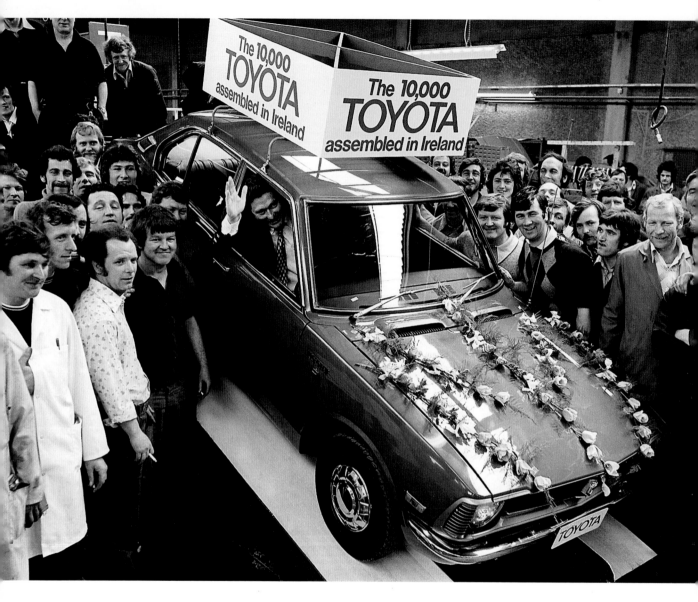

The official 'rolling-off' ceremony of the 10,000th
Toyota to be assembled at the company's plant at
John F Kennedy Park, Dublin.

26 May 1977

Opposite
Members of the Irish Army on exercise in County
Sligo are joined by an unusual new recruit.

7 September 1977

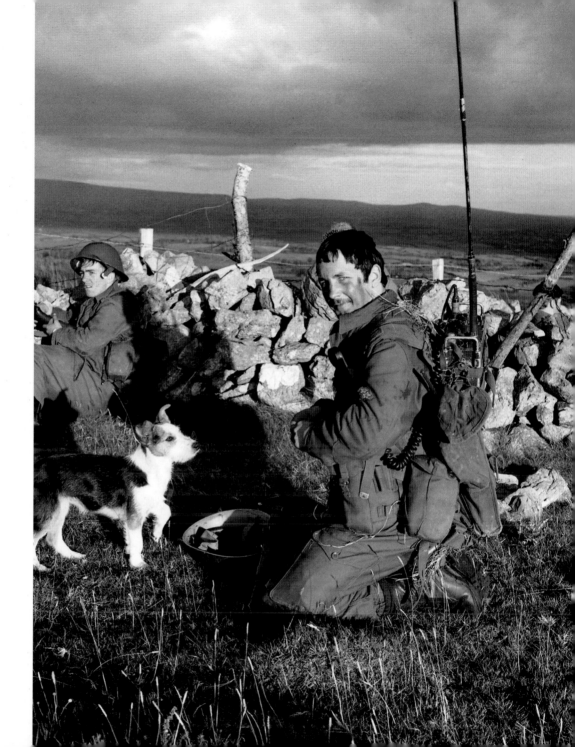

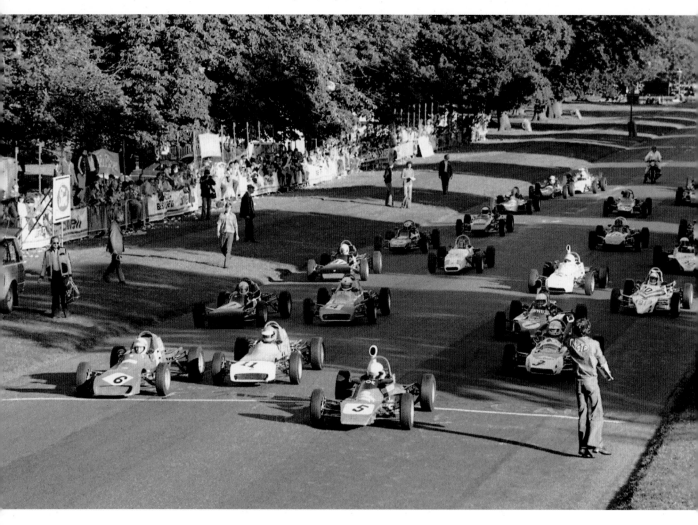

Competitors on the starting grid at the Shellsport
Formula Ford Final in the Phoenix Park. The trophy
was won by Belfast driver Trevor Templeton.

18 September 1977

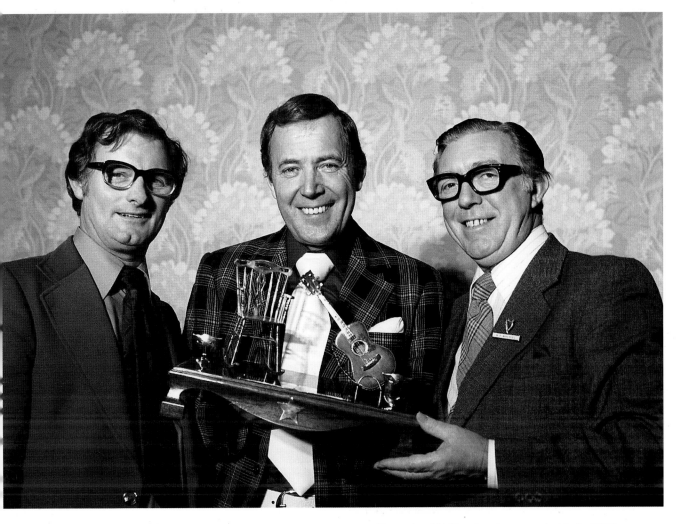

Entertainer Val Doonican is presented with the VATS
award. On the trophy are a miniature guitar and the singer's
trademark rocking chair. The Waterford-born singer has had
a very successful career in Britain, including his own BBC TV
show, 'The Val Doonican Show', that broadcast for 20 years.

10 October 1977

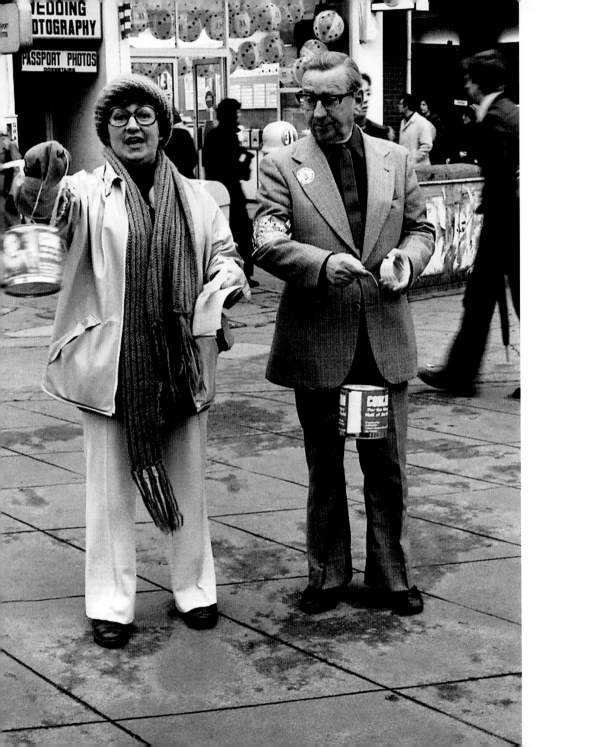

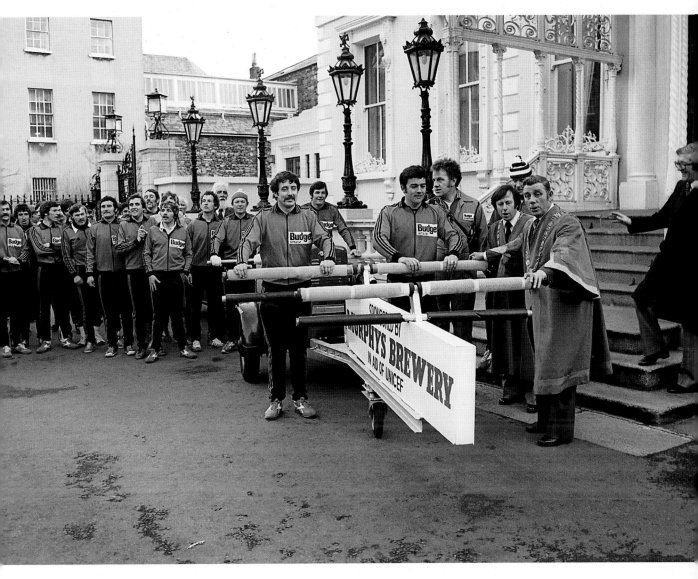

Opposite
Maureen Potter and Danny Cummins collecting for Concern.

8 December 1977

Some of the thirty-two firemen who raised money for UNICEF by pushing a fire-fighting pump from Dublin to Cork. Here they are being seen off at the Mansion House by the Lord Mayor.

29 March 1978

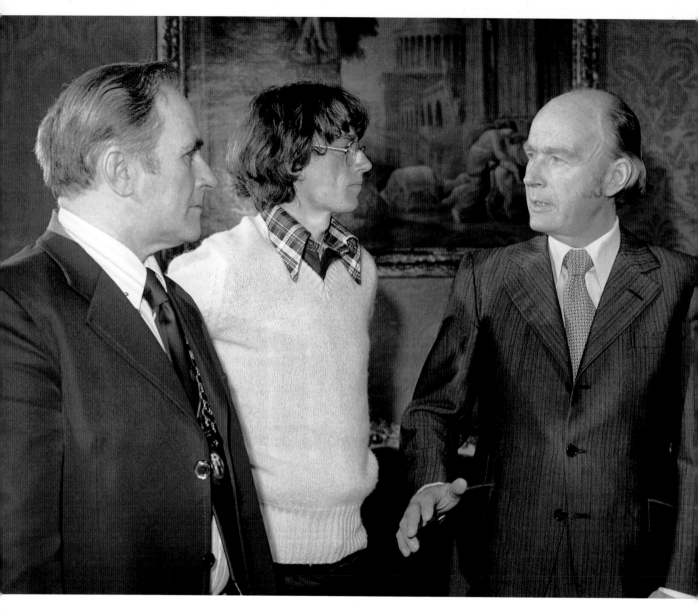

After his World Championship Cross Country win, John Treacy is received by President Hillery at
Áras an Uachtaráin. With them is Bill Coghlan, President B.L.E.

31 March 1978

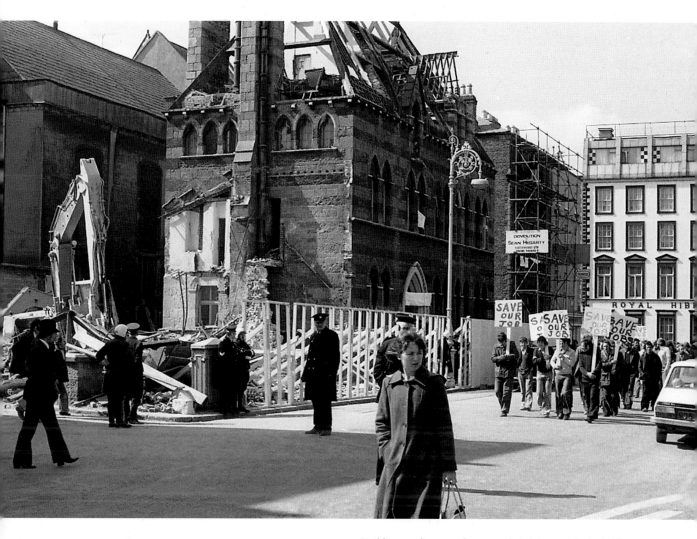

Building workers parade to save their jobs outside the half-demolished Molesworth Hall, while, inside, architectural students have staged a sit-in to 'Save our Street'.

5 April 1978

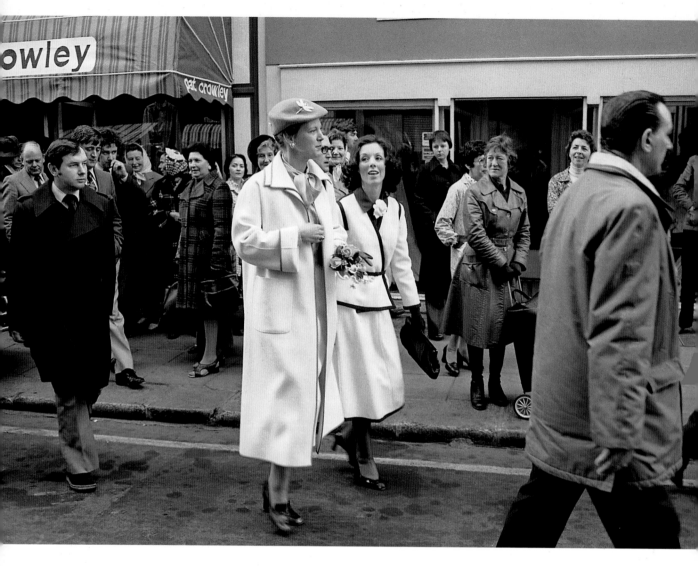

Queen Margrethe II of Denmark (in white coat)
goes shopping on Grafton Street.

27 April 1978

Opposite

(l to r) Lieut. Col. Eric Guerin, Galway, Officer Commanding, 43rd Battalion,
Robert Molloy, TD, Minister for Defence, and Fr Michael Kelly, Chaplain, at
the departure of troops for UN duty in the Lebanon.

5 June 1978

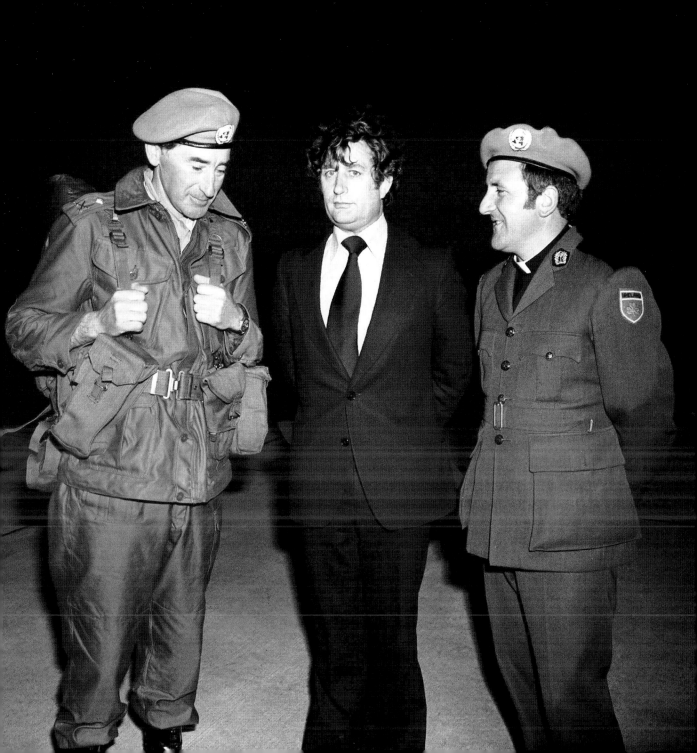

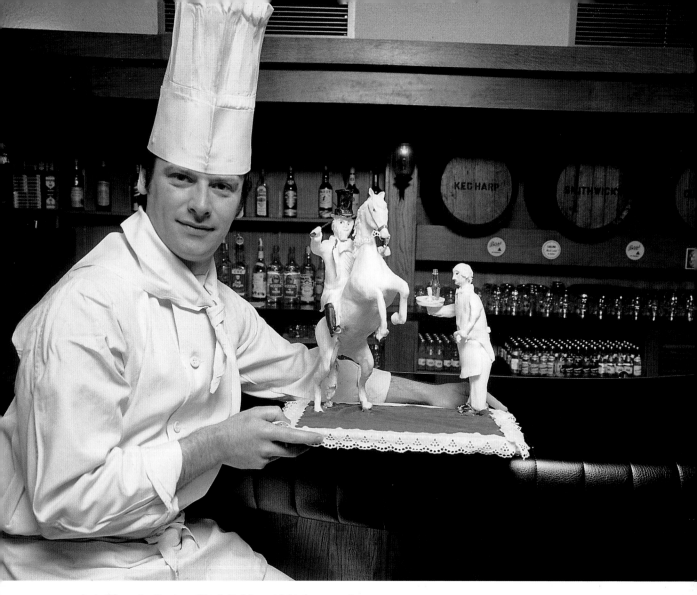

A chef from the Gresham Hotel, Dublin, with his butter sculpture of 'The Bird Flanagan'. Flanagan was a noted Dublin eccentric and prankster. He famously rode his horse in the doors of the Gresham Hotel and asked for a drink. 'It's after hours, sir', replied a porter. 'It's not for me, you fool, it's for the horse!' responded Flanagan.

7 June 1978

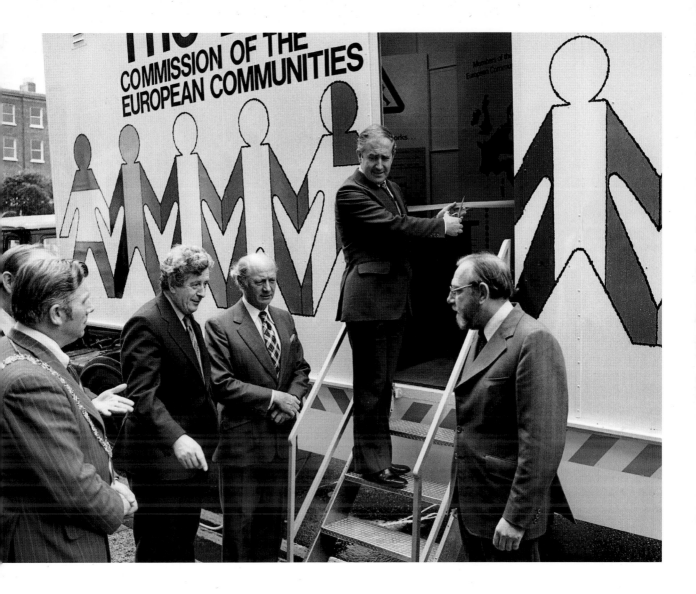

Commissioner Dick Burke cuts the ribbon to launch the EEC Roadshow, a mobile unit that toured the country. Among those in attendance are (l to r) Dr Garrett FitzGerald, TD, Leader of Fine Gael, An Taoiseach, Jack Lynch, and Frank Cluskey, TD, Leader of the Labour Party.

3 July 1978

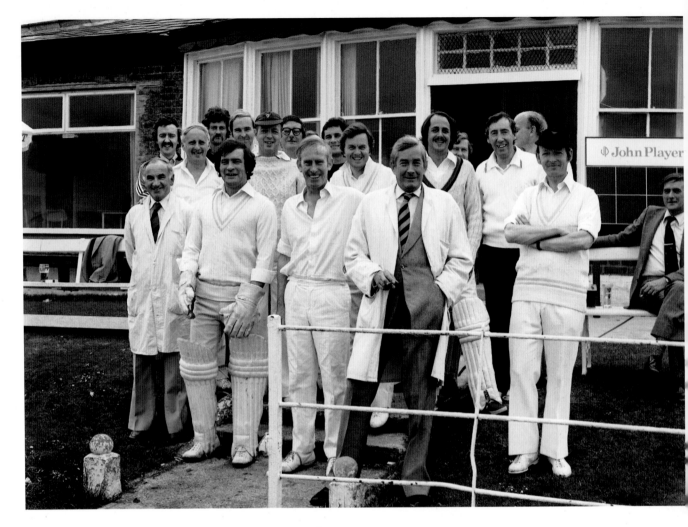

A cricket match between members of the Press and RTÉ personnel at the Phoenix Club. Among the well-known faces are Fred Cogley, (in cap and Aran jumper); next to him is the tenor Frank Patterson, and, second from right, second row, is newsreader Jim Sherwin.

18 July 1978

Opposite
Sailors in the rigging of the Italian training ship *Amerigo Vespucci*.

12 September 1978

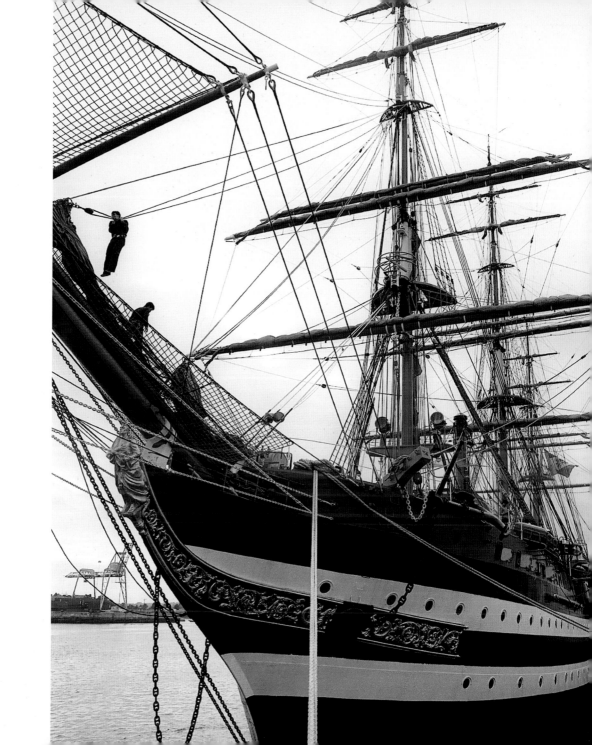

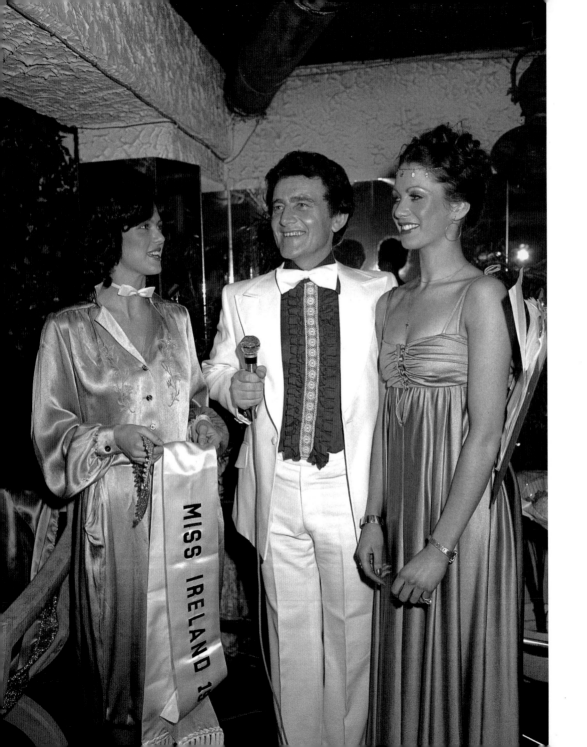

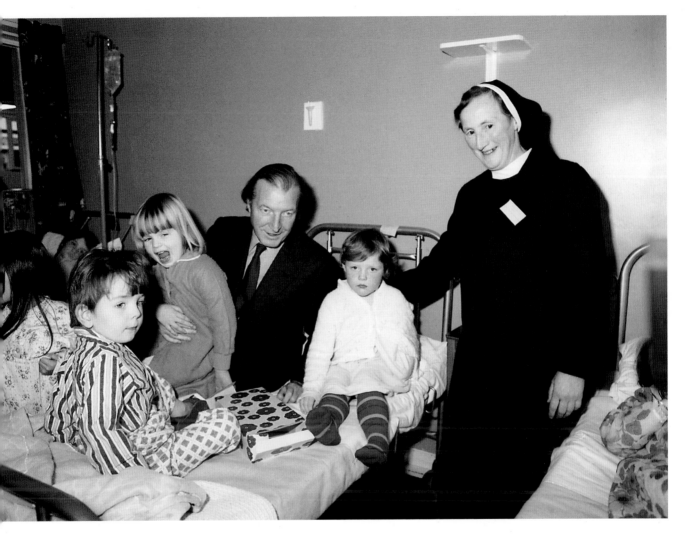

Minister for Health and Social Welfare,
Charles Haughey, with young patients at
Letterkenny County Hospital.

6 November 1978

Opposite
The winner of the Miss Ireland beauty pageant,
Lorraine Marian O'Connor (right), about to
receive her sash and crown. Centre is compere
Larry Gogan.

5 October 1978

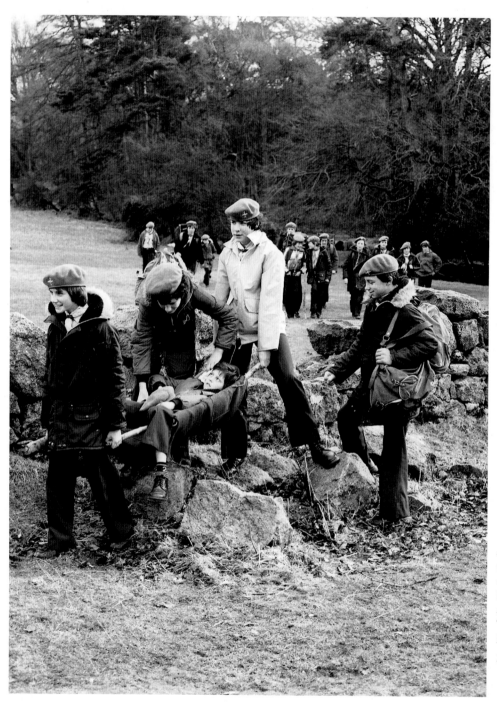

As part of their training, scouts carry a 'wounded' comrade to safety at Larch Hill, the CBSI scouting campsite at Tibradden in the Dublin Mountains.

3 March 1979

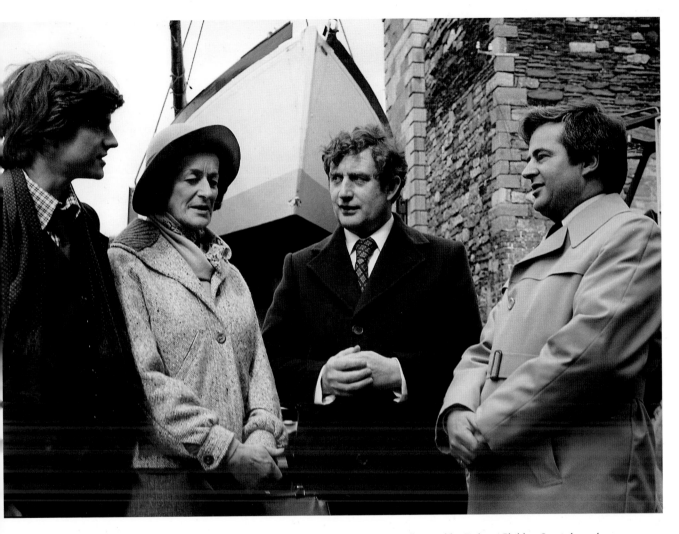

The historic yacht 'Asgard' owned by Erskine Childers Snr. is brought to Kilmainham Jail, Dublin, to be displayed as part of a future exhibition. (l to r) Daragh Moller, great-grandson of Erskine Childers, Mrs Rita Childers, wife of the former president, Robert Molloy, Minister for Defence and Raymond Cassidy, Chairman, Board of Trustees, Kilmainham Jail.

1 April 1979

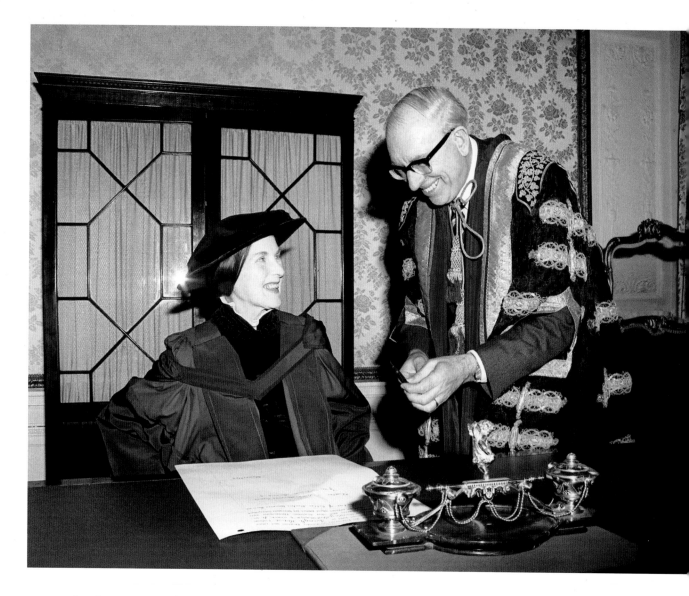

Joan Denise Moriarty, founder of professional ballet in Ireland, receives an Honorary Degree from University College Cork. Dr T K Whitaker, Chancellor of the National University of Ireland, holds the pen with which she signed the acceptance scroll.

5 April 1979

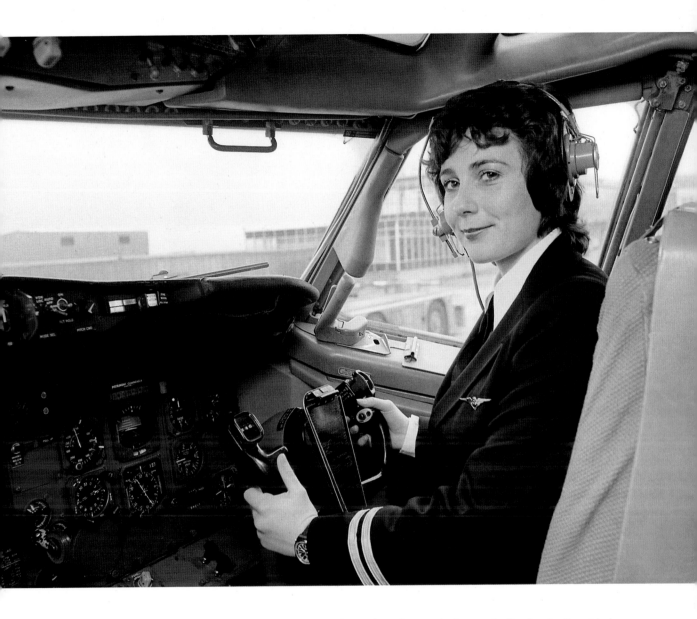

Grainne Cronin in the cockpit of a Boeing 737. Formerly a stewardess with Aer Lingus, she became the first female pilot with the airline. Ms Cronin, from Ennis, Co Clare, was the daughter of Aer Lingus Captain Phelim Cronin. She reached the rank of Captain in 1988. Her last flight saw her captain an all-female crew aboard an Airbus A330 to Boston. She retired after 33 years of service.

29 April 1979

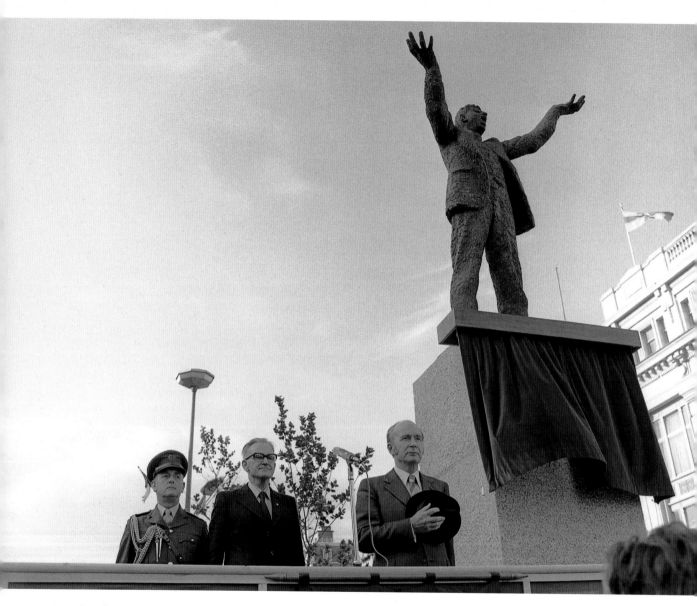

President Dr Patrick Hillery unveils a statue of Jim Larkin by sculptor Oisin Kelly on O' Connell Street, Dublin. 'Big Jim' Larkin was a trade union activist who founded the Irish Transport and General Workers Union (ITGWU) and in 1913 led workers into what became known as the Lockout when employers refused to let them join unions.

15 June 1979

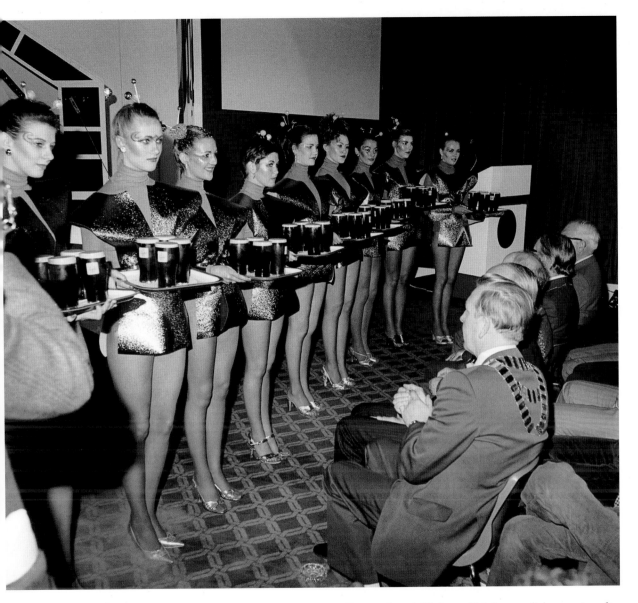

At the Guinness Theatre in St James's Gate Brewery, Guinness launch 'Guinness Light', a new, lighter version of its world famous stout. Here the 'Alien Girls' prepare to distribute the new drink to the specially invited audience. It was aimed at younger drinkers, but Guinness Light did not prove popular with the market and ultimately was phased out.

26 June 1979.

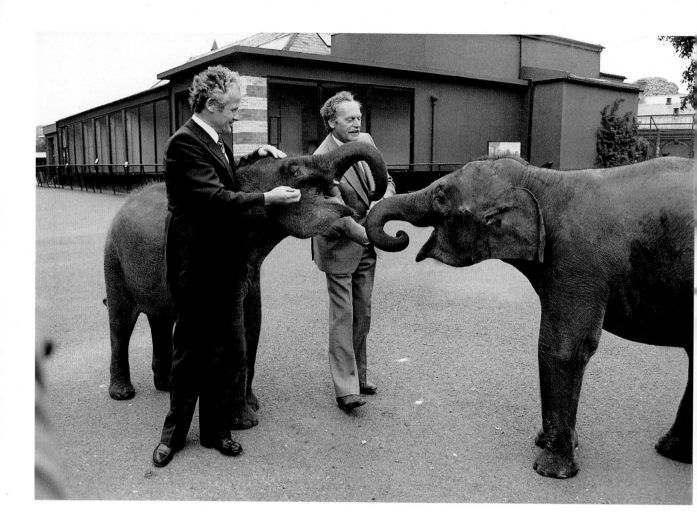

HB Ice Cream presented two baby elephants from Thailand to the Zoo. Mr Terry Murphy, Director of the Zoo, said that they had been without an elephant of their own for some time. Hearing this, HB decided to sponsor the importation of the two young elephants from Bangkok. Picture shows the baby elephants enjoying all the attention being lavished on them by Ted Murphy, MD of HB Ice Cream (left) and Terry Murphy.

9 August 1979

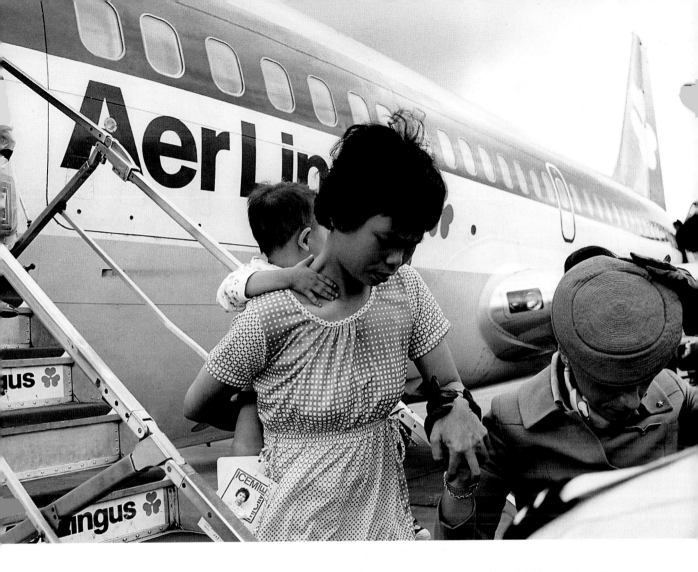

A young Vietnamese woman and her child being assisted from the aircraft by an Aer Lingus hostess. As part of a UNHCR initiative, Ireland agreed to take some of the Vietnamese (boat people) refugees. A temporary refugee centre was set up in the grounds of Blanchardstown Hospital to accommodate the families, from where they were assimilated into the community.

9 August 1979

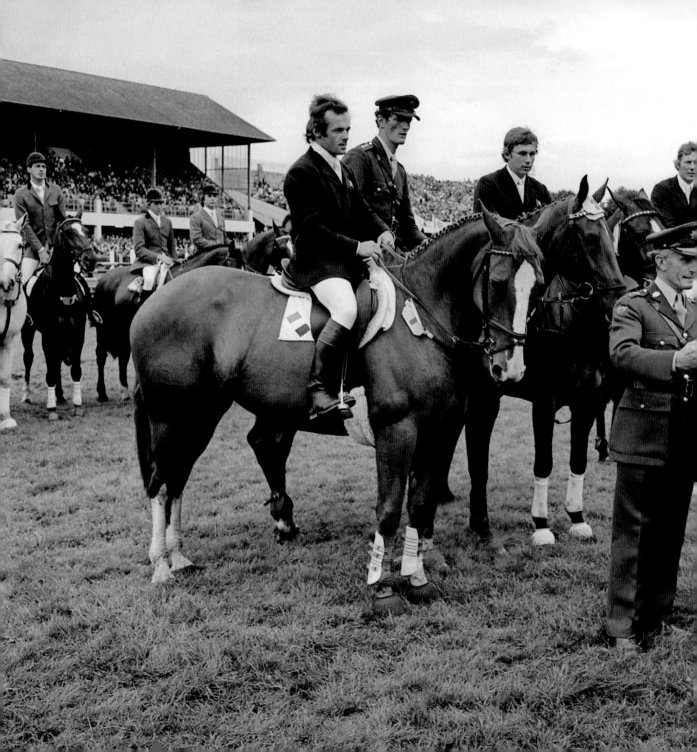

Col. Billy Ringrose, Chef d'Equipe of the Irish showjumping team, being presented with the Aga Khan trophy by President Hillery. It was the first time since 1937 that Ireland got to keep the trophy, having won the competition three times in succession. The team comprised (l to r) Paul Darragh on Heather Honey, Captain Con Power on Rockbarton, James Kernan on Condy and Eddie Macken on Boomerang.

10 August 1979

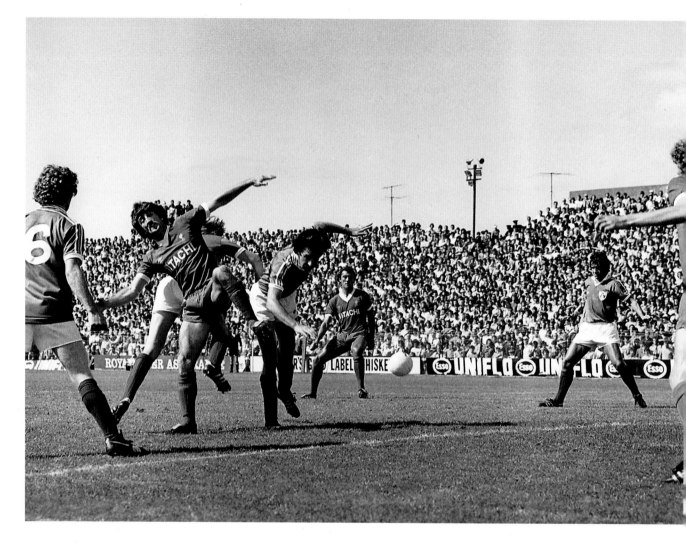

In a pre-season friendly, the League of Ireland took on Liverpool FC at Dalymount Park. The team was made up of players from several League of Ireland clubs and captained by the legendary John Giles. Liverpool won the game by 2 - 0. Ray Treacy is on right of picture, while Liverpool's Terry McDermott (2nd from left) adopts a balletic pose as he attempts to get the ball.

18 August 1979

Opposite
Mr Louis Copeland, the renowned tailor and men's outfitter, pictured at his Dublin store on Capel Street.

14 September 1979

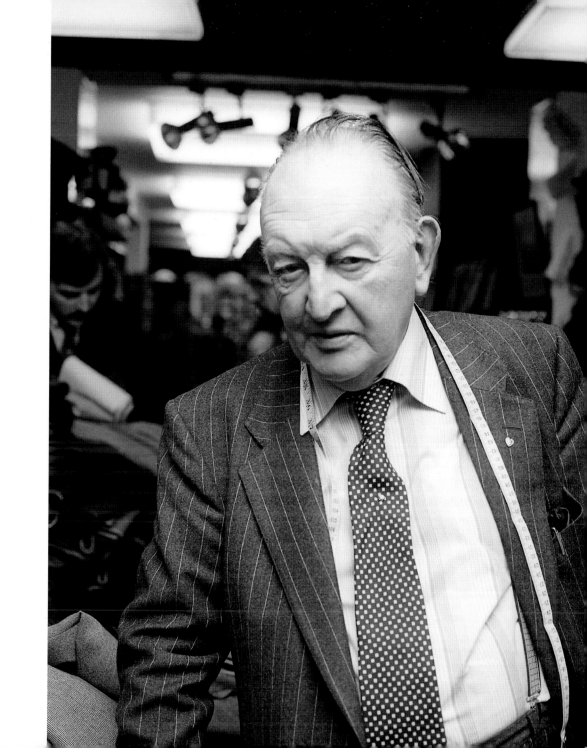

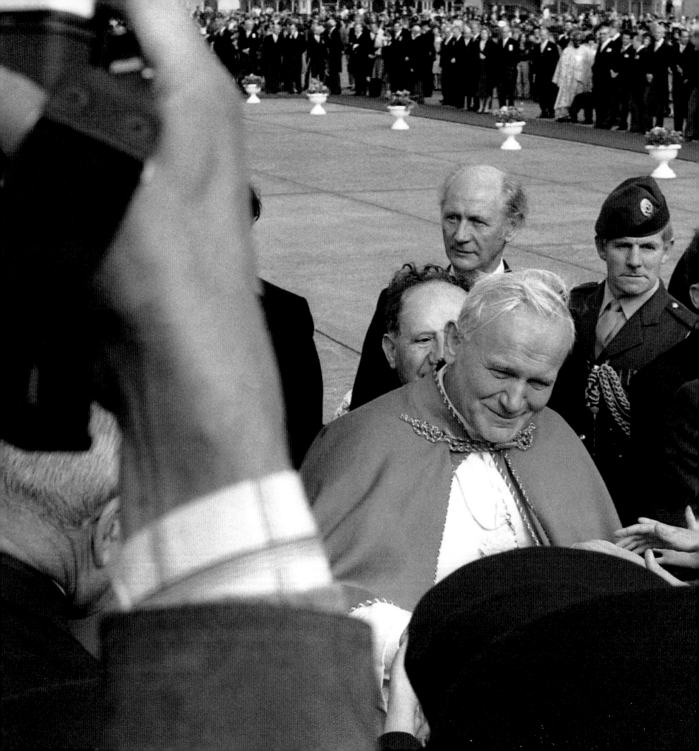

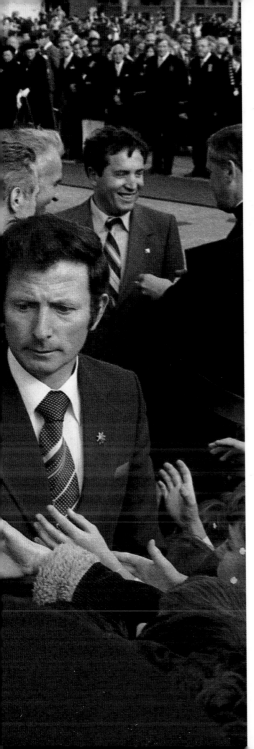

Pope John Paul II greets the crowds who turned up at Dublin airport to welcome him at the start of his three-day visit to Ireland. Behind him (partly obscured) is Papal Nuncio Archbishop Gaetano Alibrandi, and behind the archbishop is Taoiseach Jack Lynch.

29 September 1979

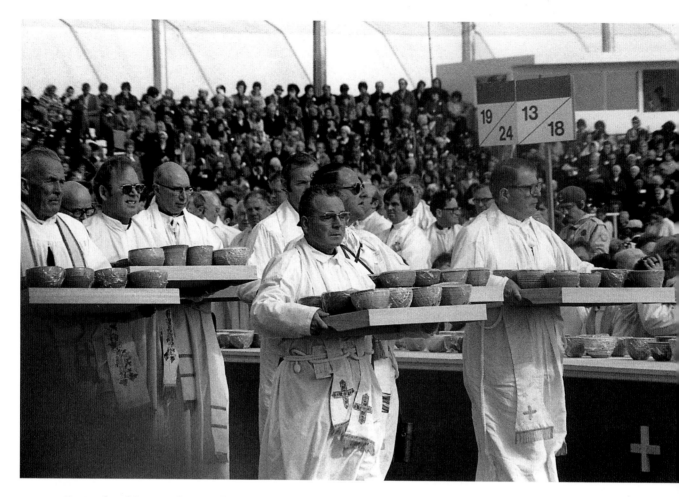

During the celebration of Mass at the Phoenix Park, clergy carry bowls containing the Hosts to be distributed to the congregation.

29 September 1979

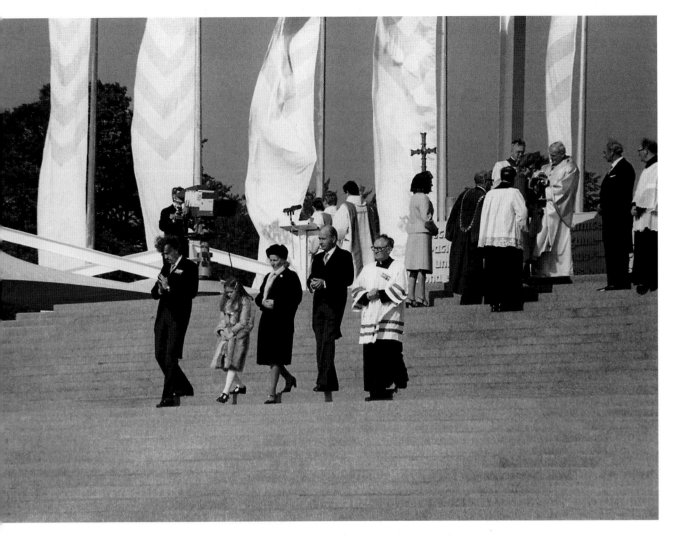

President and Mrs Hillery, with their daughter,
Vivienne and son John, descend the steps of
the specially-constructed altar in the Park,
having received Communion from the Pontiff.

29 September 1979

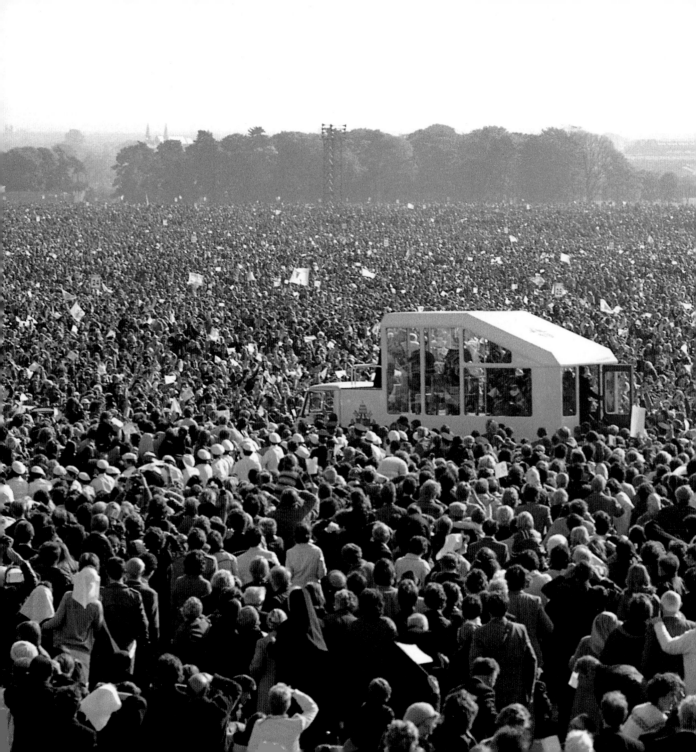

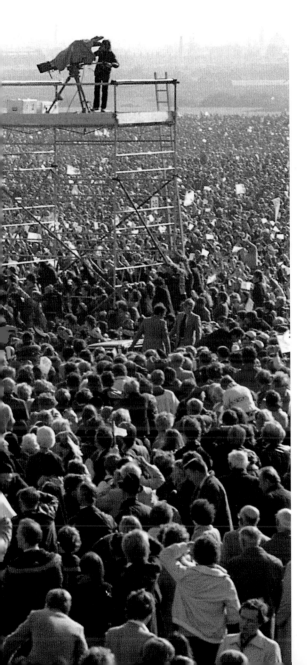

The Pope (centre of pic) makes his way on the 'Popemobile' through the vast crowds assembled in the Phoenix Park. It is estimated that well over 1 million people gathered in the Park to see the Pope. From Dublin he travelled to Drogheda and on the 30th he addressed 285,000 people at a youth rally in Galway, before travelling to Knock, County Mayo. He said Mass to another huge crowd in Limerick, before departing through Shannon airport.

29 September 1979

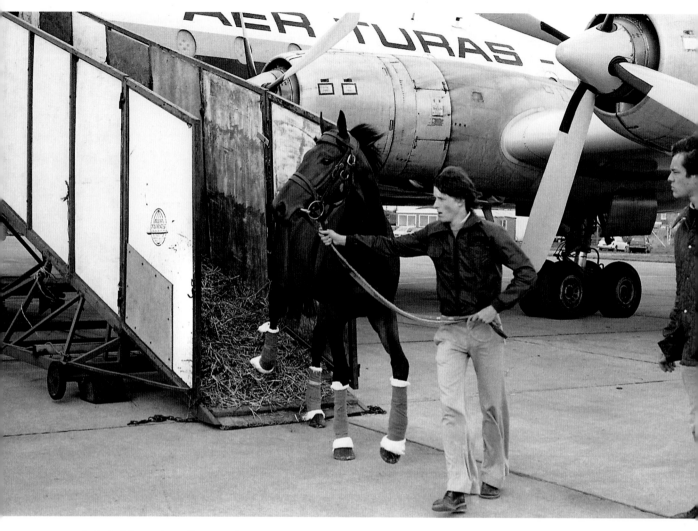

Arrival of the racehorse Torus to take part in
the Irish St Leger at the Curragh. The race was
won by Niniski, the mount of Willie Carson.

11 October 1979

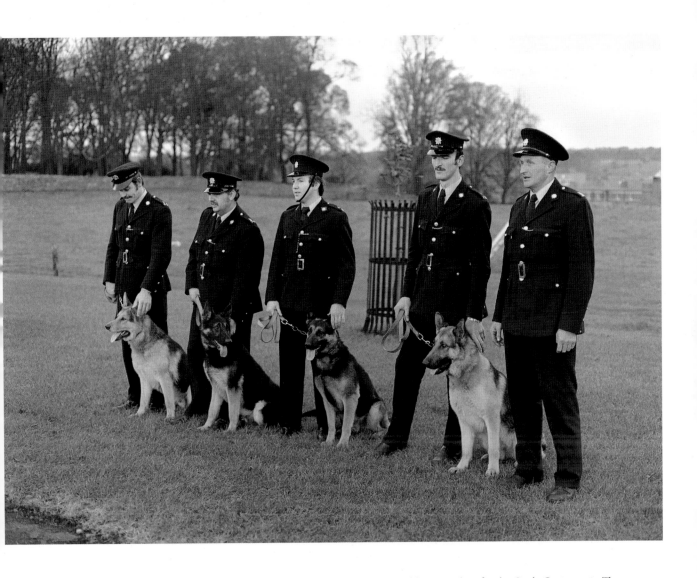

The passing out of four new dogs for the Garda Canine unit. The new recruits parade with their handlers (l to r): Garda Pat Griffin, Tralee, Co Kerry with 'Sam', Garda Vincent Turner, Limerick, with 'Glenn', Garda John Culkin, Ballina, Co Mayo with 'Rover', Garda Thomas Donnelly, Raheny, Dublin with 'Duke' and Sergeant Brendan Maher, Wexford, who is in charge of the canine unit.

22 November 1979

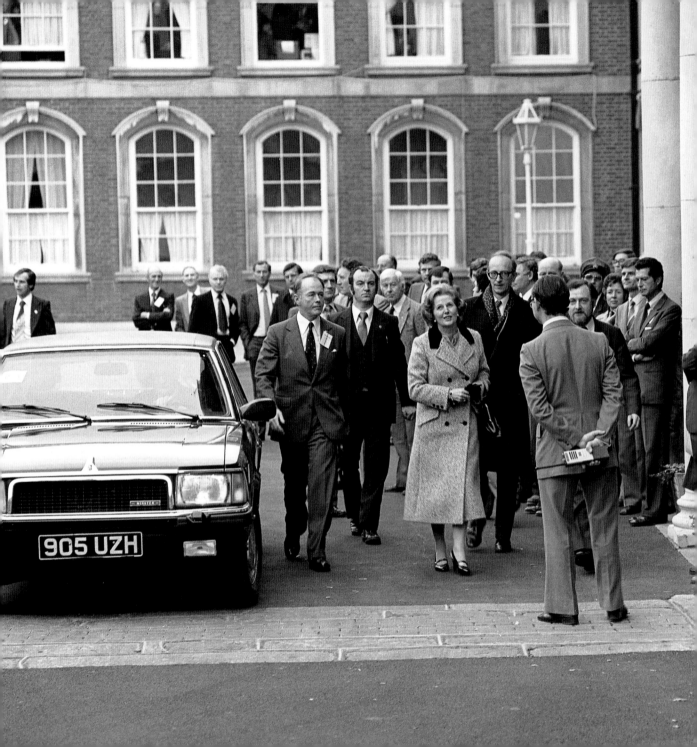

British Prime Minister Margaret Thatcher arrives at
Dublin Castle to take part in the EEC Leaders' summit.

29 November 1979

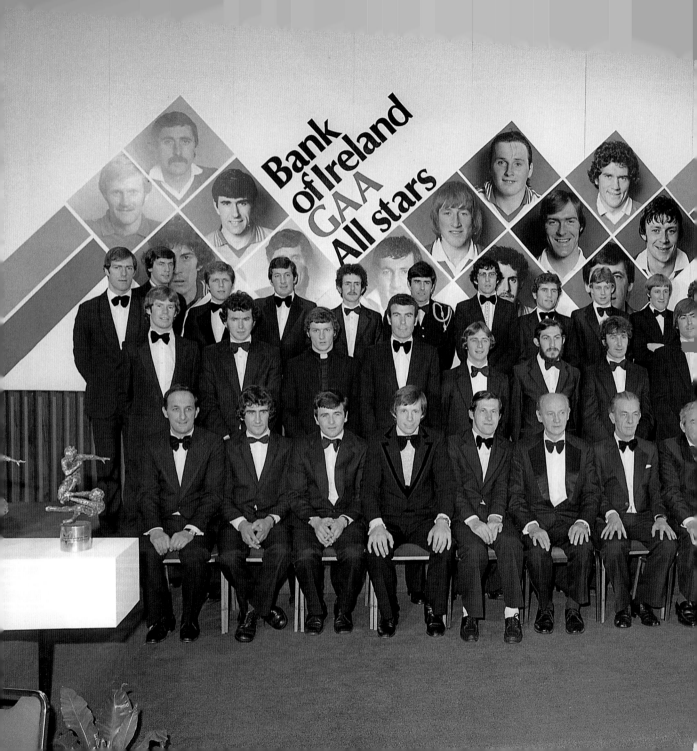

The 1979 Bank of Ireland GAA Allstars received their trophies from An Taoiseach, Jack Lynch. Front row (l to r) John Neiland, Director, Bank of Ireland, Pat McLoughney, Tipperary, Brian Murphy, Cork, Martin O'Doherty, Cork, Liam Mulvihill, Director General, GAA, Taoiseach Jack Lynch, Frank O'Rourke, Director, Bank of Ireland, Paddy McFlynn, President, GAA, Tadhg O'Connor, Tipperary, Mick Dunne, Hon Sec. Selection Committee. Middle row, Dermot McCurtain, Cork, Ger Henderson, Tipperary, Iggy Clarke, Galway, John Connolly, Galway, Joe Hennessey, Kilkenny, John Callinan, Clare, Liam O'Brien, Kilkenny, Joe Mc Kenna, Limerick, Paddy Cullen, Dublin, Eugene Hughes, Monaghan. Back row, John O'Keeffe, Kerry, Tom Heneghan, Roscommon, Tommy Drumm, Dublin, Tim Kennelly, Kerry, Danny Murray, Roscommon, Dermot Earley, Roscommon, Bernard Brogan, Dublin, Ger Power, Kerry, Sean Walsh, Kerry, Pat Spillane, Kerry, Michael Sheehy, Kerry, Joe McGrath, Mayo.

7 December 1979

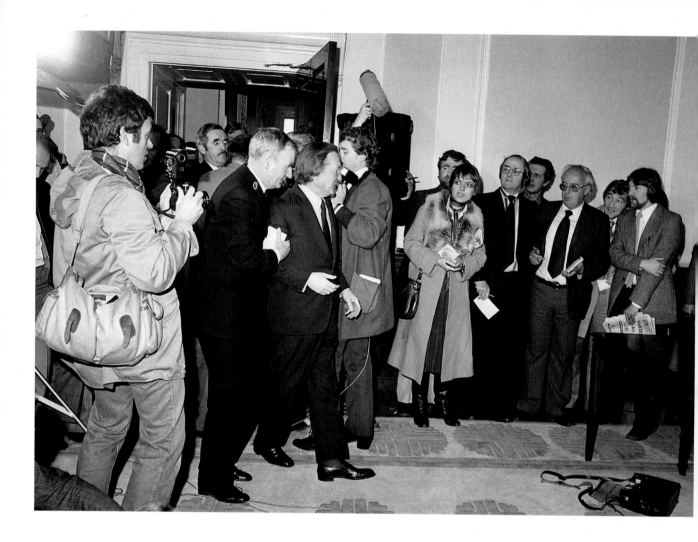

In early December Jack Lynch resigned as Taoiseach and leader of Fianna Fáil. The leadership contest that resulted was a two-horse race between Charles Haughey and the Tánaiste, George Colley. Haughey won by a margin of 44 votes to 38. Here the newly-elected leader is ushered through the media on his way to the formal announcement.

7 December 1979

Louis Marcus, (right) directs a documentary film on the 1916 leader, Padraig Pearse – Revival: Pearse's Concept of Ireland, to mark the centenary of Pearse's birth. Centre is actor John Kavanagh, who played the part of Pearse.

13 December 1979

Also available

The 1950s

Ireland in Pictures

An evocative collection of photographs of the customs, fashions, sporting events, everyday family and working lives, celebrity visitors, momentous times, high days and holy days of a simpler decade in our country's history.

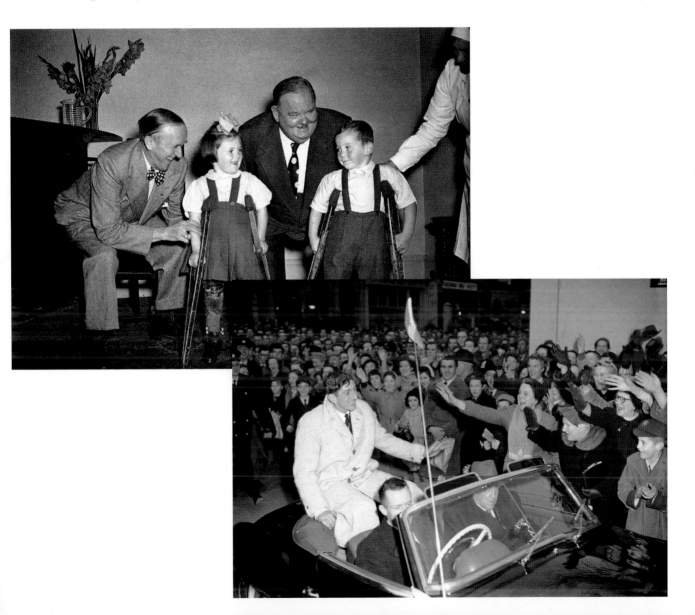

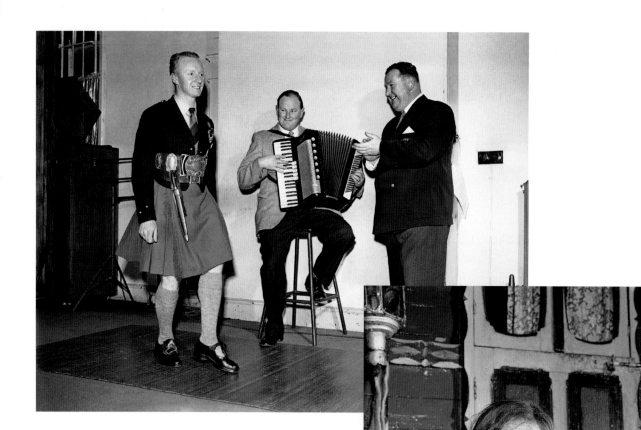

Images from

The 1950s
Ireland in Pictures

Also available

The 1960s

Ireland in Pictures

A unique collection of photographs that captures the essence of a decade of change in Irish life and will bring back memories of the people, personalities, events – big and small – that shaped the period.

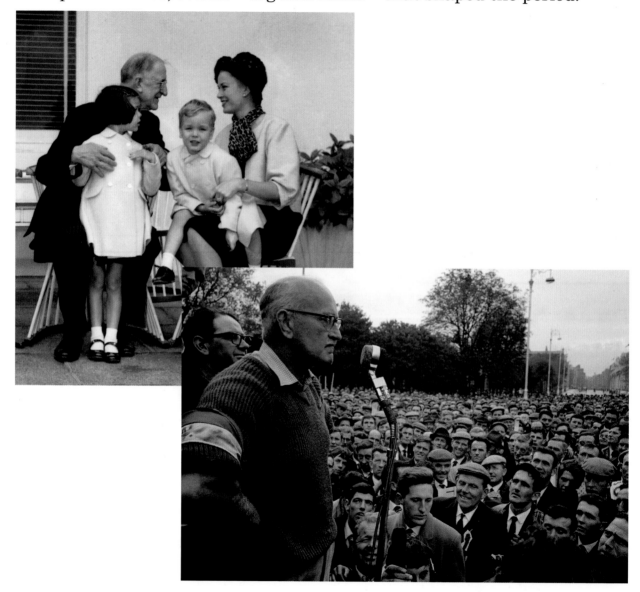

Images from

The 1960s
Ireland in Pictures

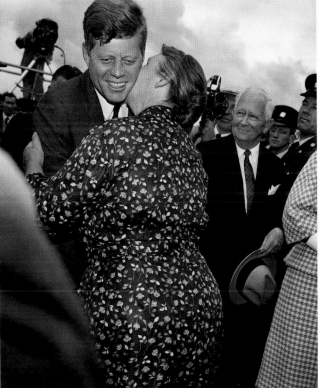